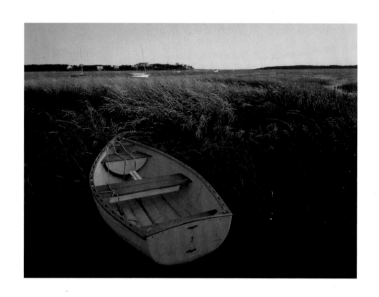

CAPE COD
AND MARTHA'S VINEYARD

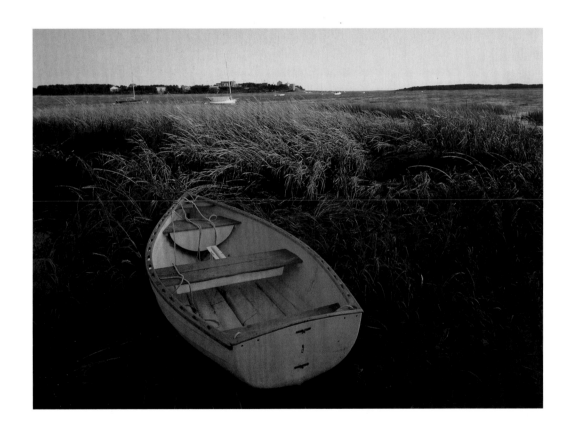

WHITECAP BOOKS

Text by Tanya Lloyd Kyi
Edited by Elaine Jones
Photo editing by Tanya Lloyd Kyi
Proofread by Lisa Collins
Cover and interior layout by Jacqui Thomas

Printed and bound in Canada

National Library of Canada Cataloguing in Publication Data

Kyi, Tanya Lloyd, 1973–

 Cape Cod and Martha's Vineyard

 (America series)
 ISBN 1-55285-324-1

 1. Cape Cod (Mass.)—Pictorial works. 2. Martha's Vineyard
(Mass.)—Pictorial works. I. Title. II. Series: Kyi, Tanya Lloyd, 1973- America series.
F72.C3K94 2002 974.4'92044'0222 C2002-910077-1

The publisher acknowledges the support of the Canada Council and the Cultural
Services Branch of the Government of British Columbia in making this publication
possible. We acknowledge the financial support of the Government of Canada through
the Book Publishing Industry Development Program for our publishing activities.

**For more information on the America Series and other Whitecap Books
titles, please visit our web site at www.whitecap.ca.**

Cape Cod is an arm curling into the Atlantic, separated from the Massachusetts mainland by a rich seafaring history and a fierce sense of independence. It is a land steeped in stories of shipwrecked sailors and marauding pirates, whaling ship captains and lightkeepers, vacationing presidents and artists in retreat.

The Cape was born in an ice age 22,000 years ago. Giant walls of ice descended toward the Atlantic, pushing layers of rocky debris before them. This debris formed the peninsula and the islands of Martha's Vineyard and Nantucket to the south. In the eras since, waves have sculpted offshore shoals and shallows so treacherous that dozens of ships lie beneath the waters. The wind sweeps over rolling dunes, rugged bluffs, white sand beaches, and cliffs hundreds of feet high.

It was this landscape that the Pilgrims sighted at the end of their Atlantic crossing in 1620. They sailed around the northern tip of the Cape and landed in the protected harbor now known as Provincetown. After exploring the region, they chose Plymouth as their new home and drafted the Mayflower Compact, a list of rules for governing their New World colony. The Wampanoag native people who lived along the shores showed the new arrivals how to farm, how to fish and hunt, how to harpoon a whale. Soon, there were villages in bays along the Cape. As the commercial fishing and whaling industries boomed, sea captains' homes sprang up along the shores and canneries lined the harbors.

When petroleum replaced whale oil in the lamps of the world, the whaling industry began its long decline. Yet the buildings of Cape Cod's first heyday—the Victorian homes with their widow's walks, the fishers' shacks, and the grist mills—survive today. These historic sites, together with the endless white sand beaches, the natural heritage preserved by Cape Cod National Seashore, and the shops and artists' galleries that line the quaint village streets, draw tens of thousands of visitors to the area each summer. And so Cape Cod enjoys a second era of prosperity, this time as artists' retreat and vacationers' paradise.

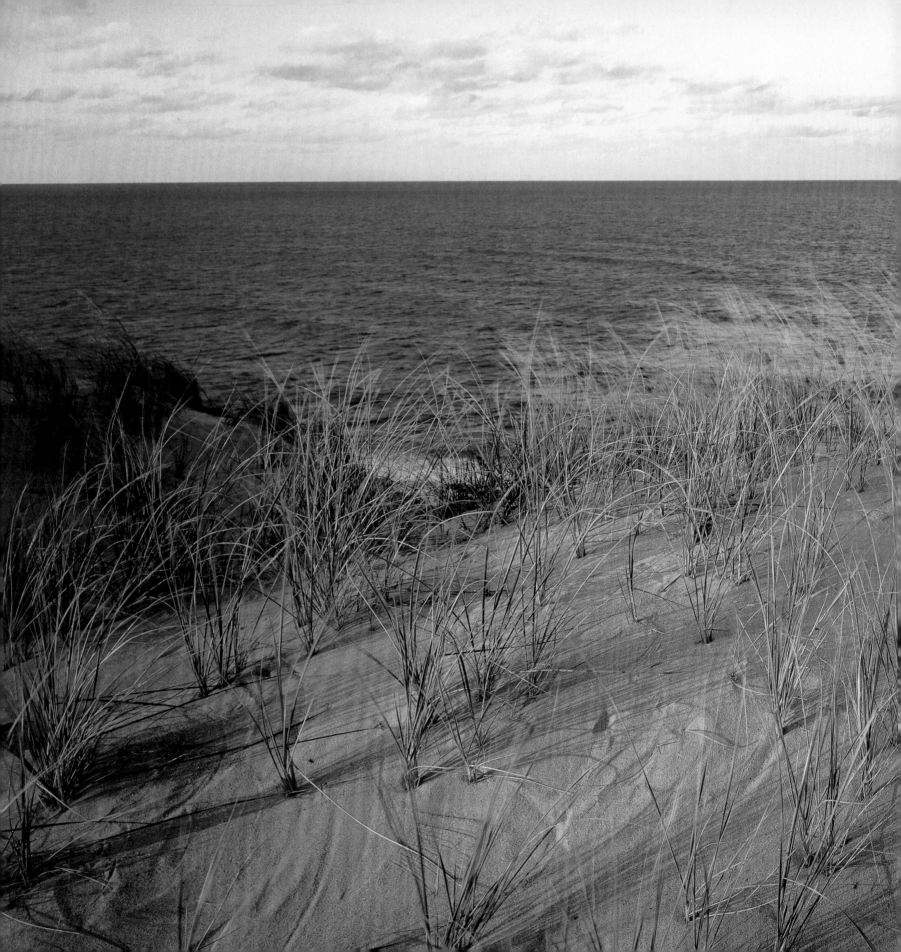

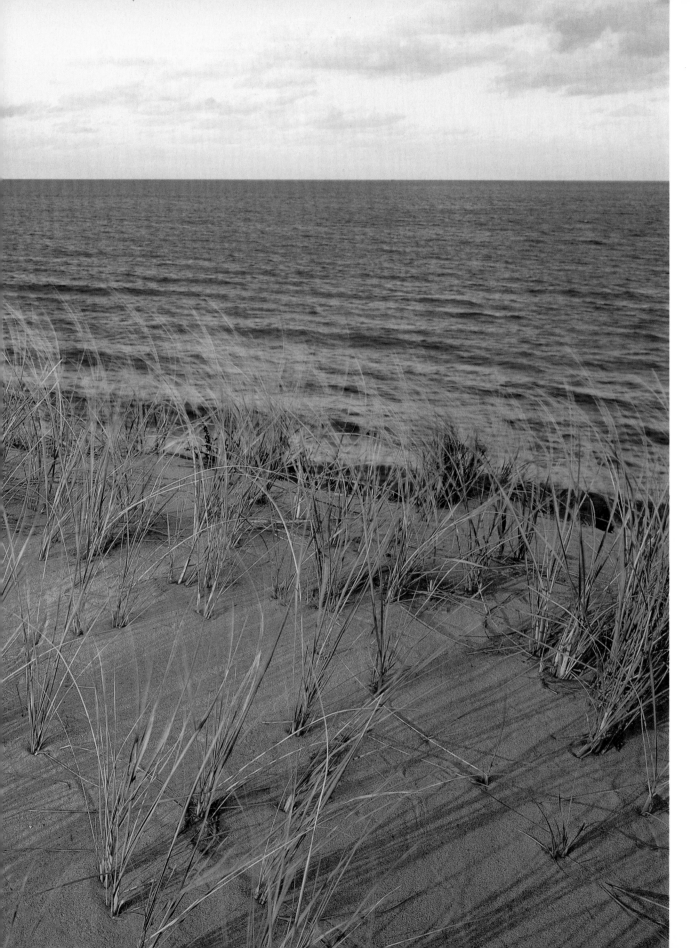

Henry David Thoreau called Cape Cod "the bared and bended arm of Massachusetts." Along that thin arm, the shoreline ranges from rocky cliffs and barren, windswept beaches to sheltered coves perfect for sunbathing. Inland, about 365 freshwater ponds, legacies of the last ice age, support teeming communities of plant and animal life.

7

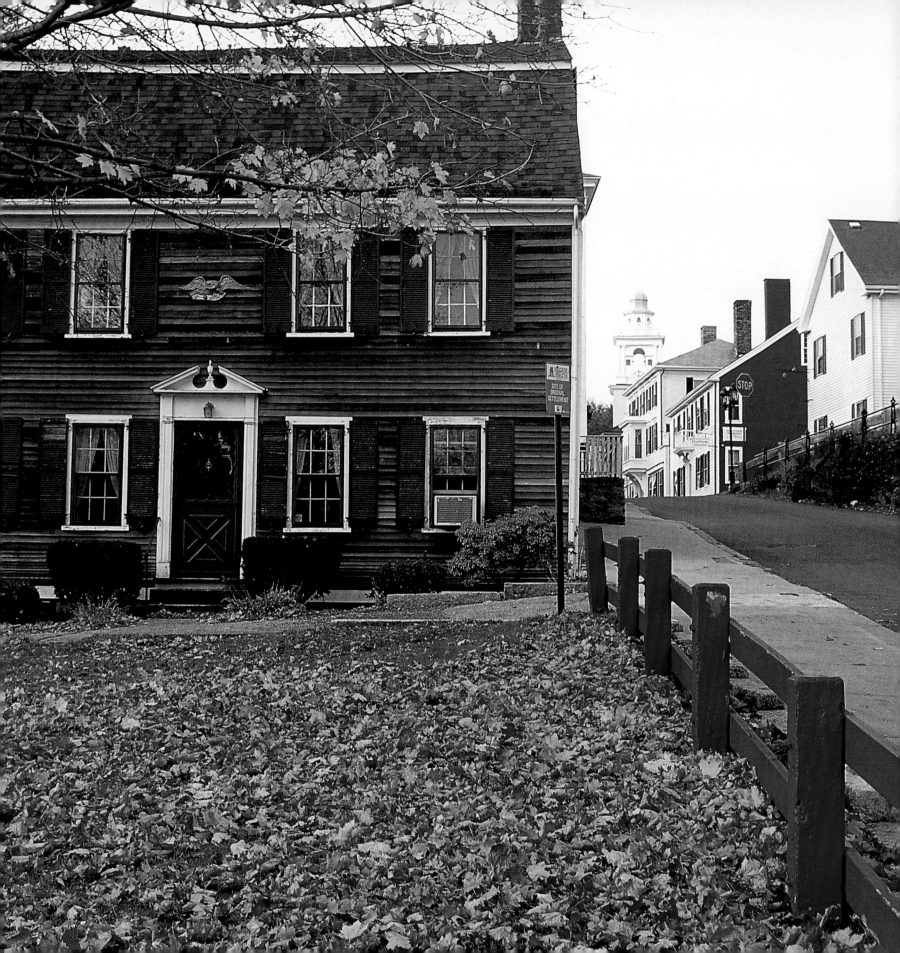

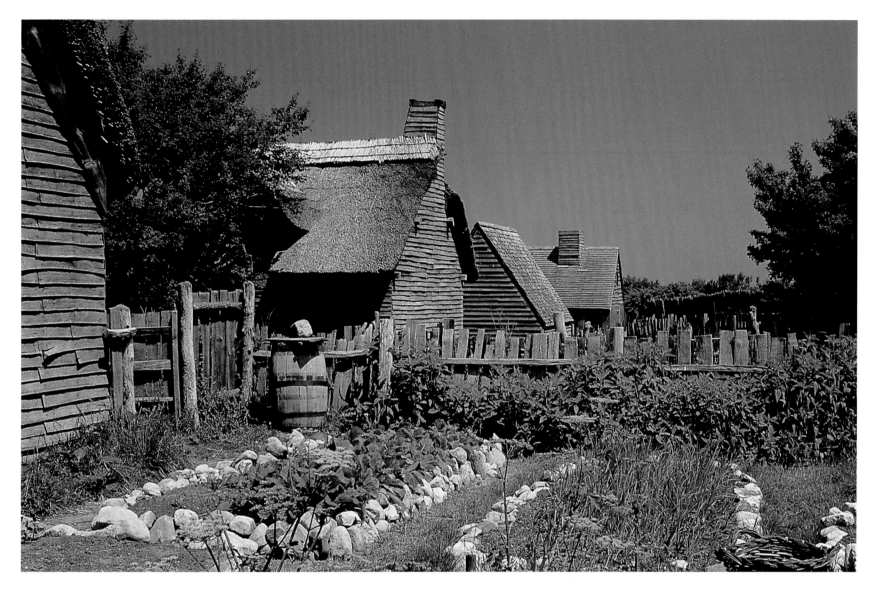

Visitors to Plymouth find themselves amid a busy day's work in the pioneer community. Costumed staff tend gardens, feed farm animals, prepare meals, and even speak in the various dialects of the Pilgrims.

When the Pilgrims settled in Plymouth in 1620, they founded the first permanent European settlement in New England. Within a decade, the well-established community had constructed outdoor ovens, wood houses, livestock shelters, and fortifications.

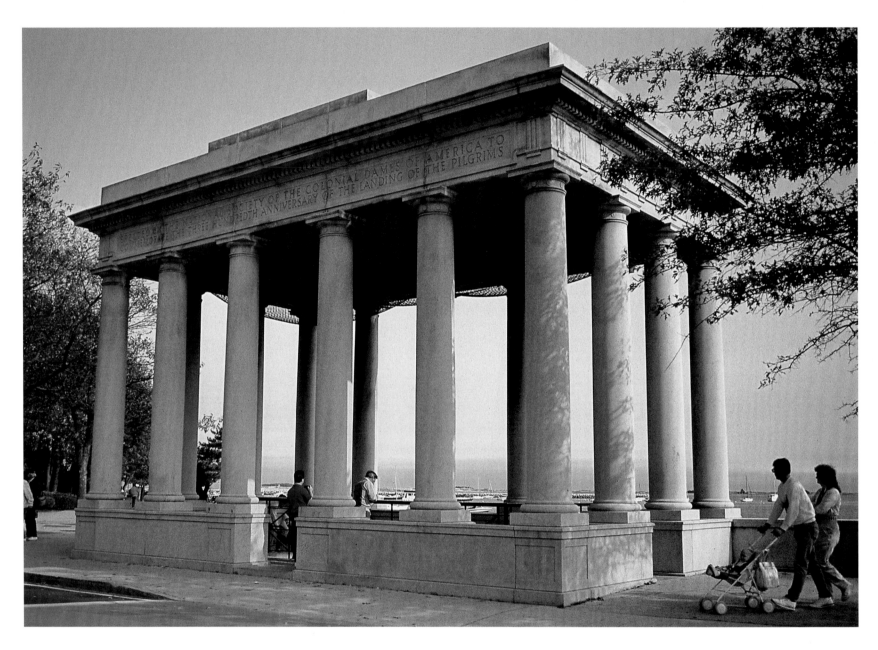

Plymouth Rock—the legendary stone where Pilgrims took their first
steps in the New World—is no longer in its original state. The rock
broke in 1774 when preservationists tried to remove it from the
beach, and it broke again in 1921 en route to its new home along the
Plymouth waterfront. The patched-up memorial bears the carving
"1620," the date the Pilgrims landed.

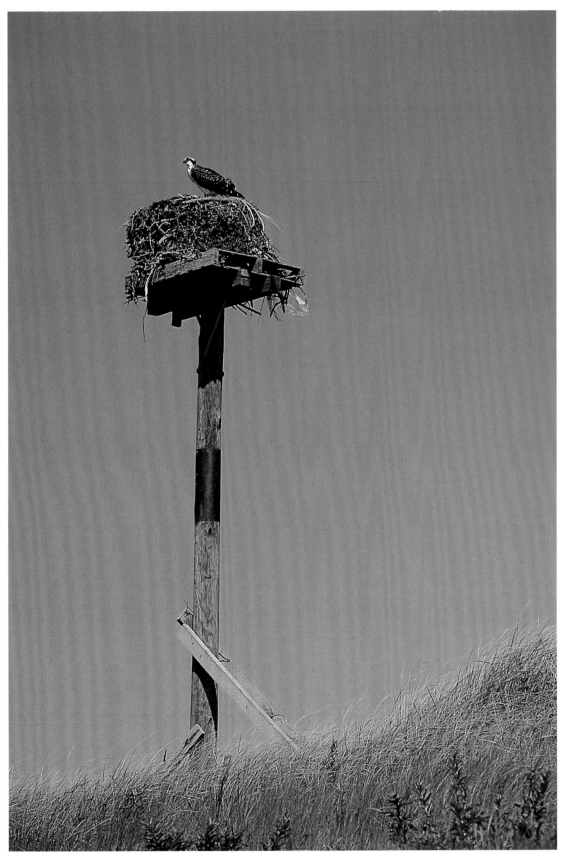

An artificial platform offers a safe nesting place for this osprey, one of the species protected by the 2,500-acre Waquoit Bay National Estuarine Research Reserve near Falmouth. Other species that find refuge within the ocean waters and wetlands of the park include herons, mute swans, eels, scallops, clams, and blue crabs.

11

The panoramic views from Sandwich's boardwalk are not its only attraction. After a 1991 hurricane destroyed the board-walk that previously connected the town to the nearby beach, residents contributed planks to build a new one. Each board bears a personal message from its donor.

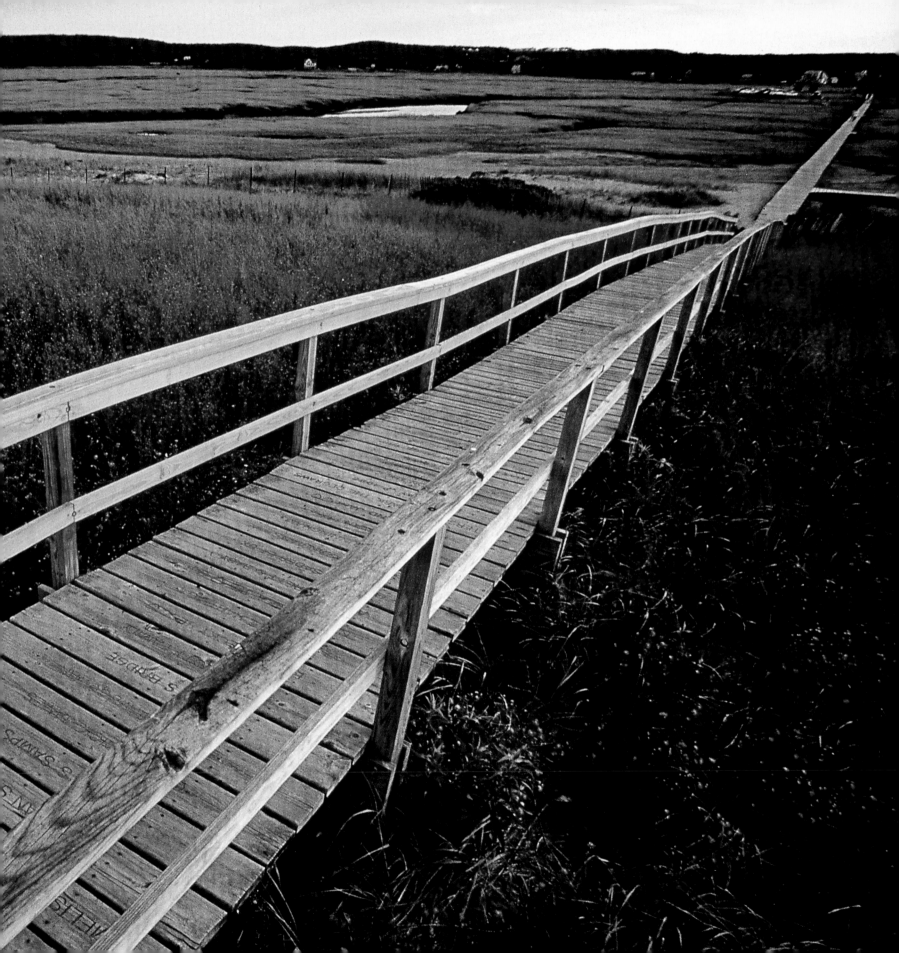

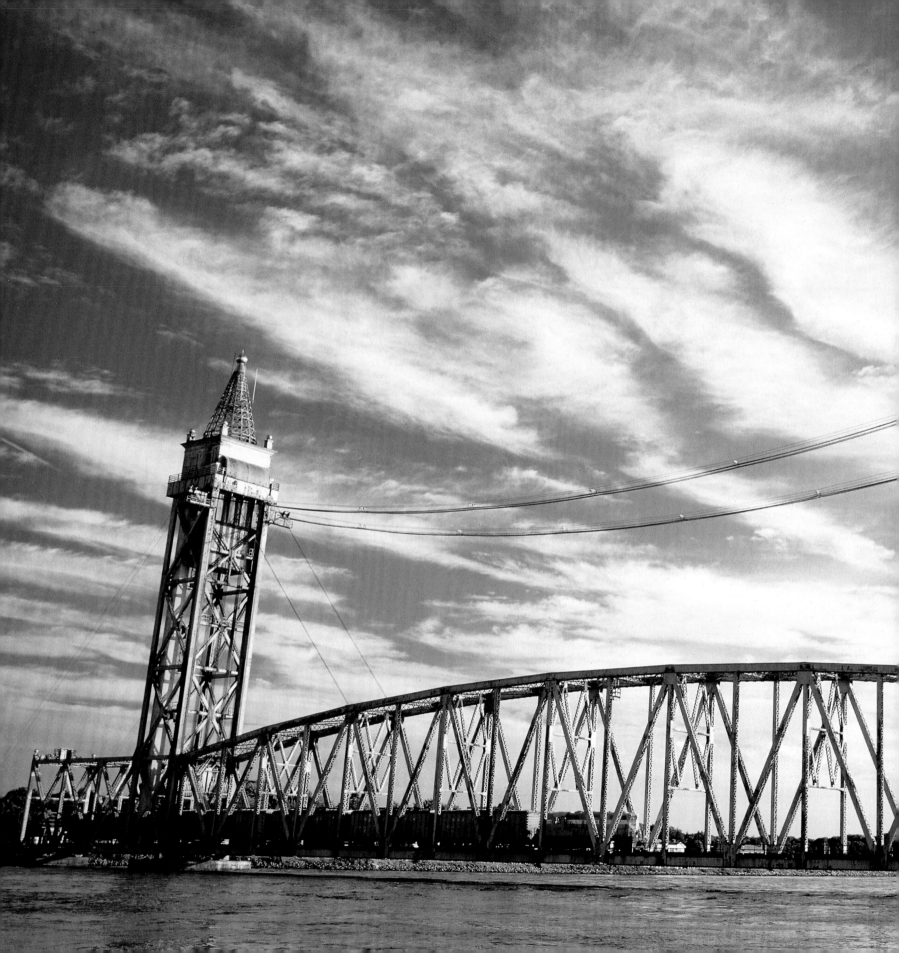

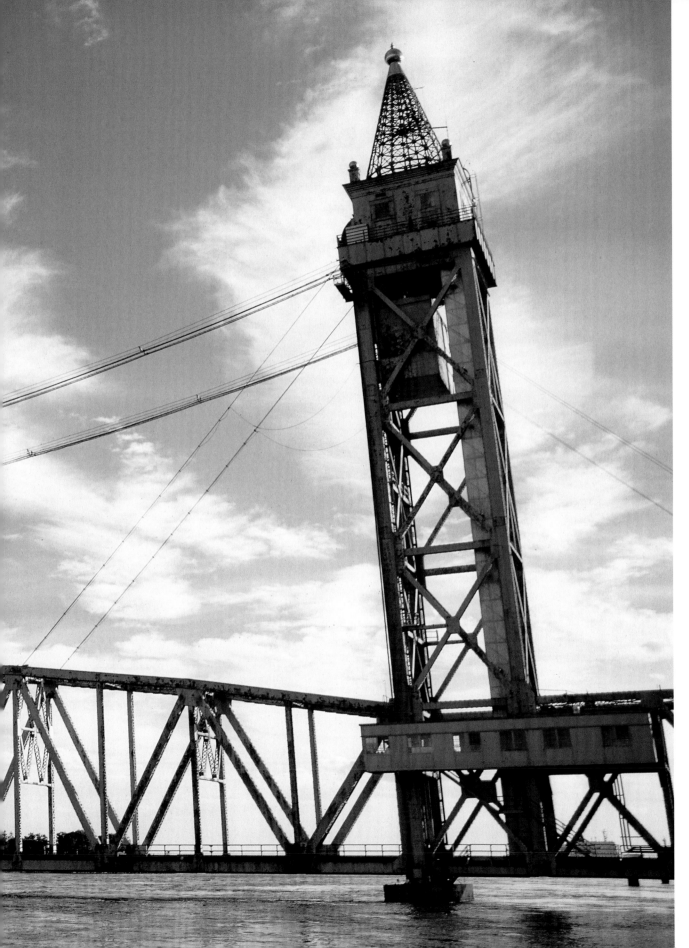

The Pilgrims wrote of the advantages of a canal between Buzzards Bay and Cape Cod Bay. George Washington considered building one also. But it wasn't until 1907, when financier Augustus Belmont's crews began digging, that the vision became reality. Today, most visitors to the Cape cross the 480-foot-wide waterway (the widest sea-level canal in the world) on one of several bridges.

15

A carved wooden lobster-man welcomes guests to a home in Woods Hole. This charming harbor town serves both as a gateway to Martha's Vineyard (ferries cross Vineyard Sound to the island) and as a scientific center. Marine life research began here in 1871 and the community is now home to the Woods Hole Oceanographic Institution and laboratories of the United States Geological Survey.

FACING PAGE–
The Nobska Lighthouse bears a wreath for the holidays and for Falmouth's annual Christmas-by-the-Sea celebrations. The beacon was built in 1876, replacing an earlier 1828 tower. Though the lighthouse is now auto-mated, the quaint keeper's quarters are inhabited by the local Coast Guard commander.

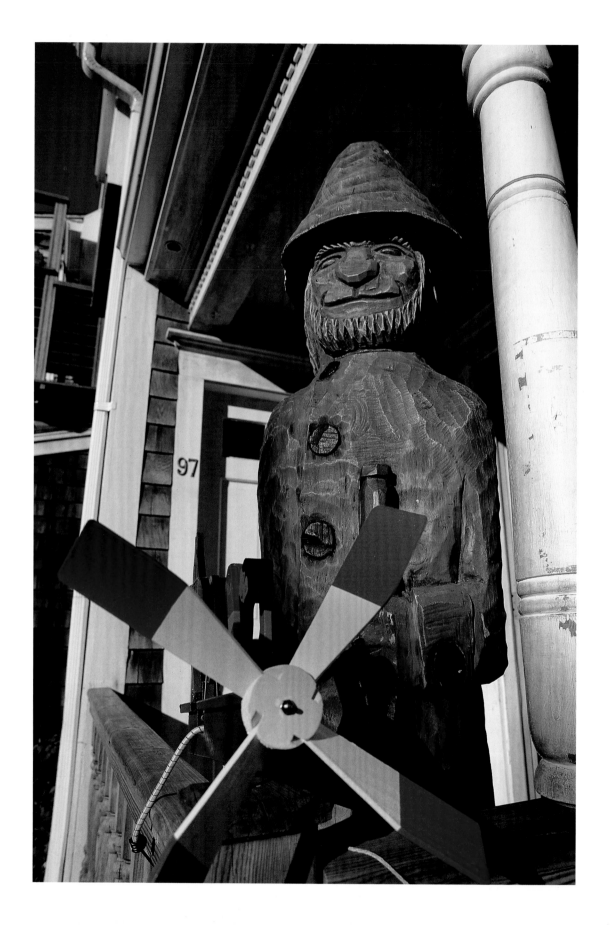

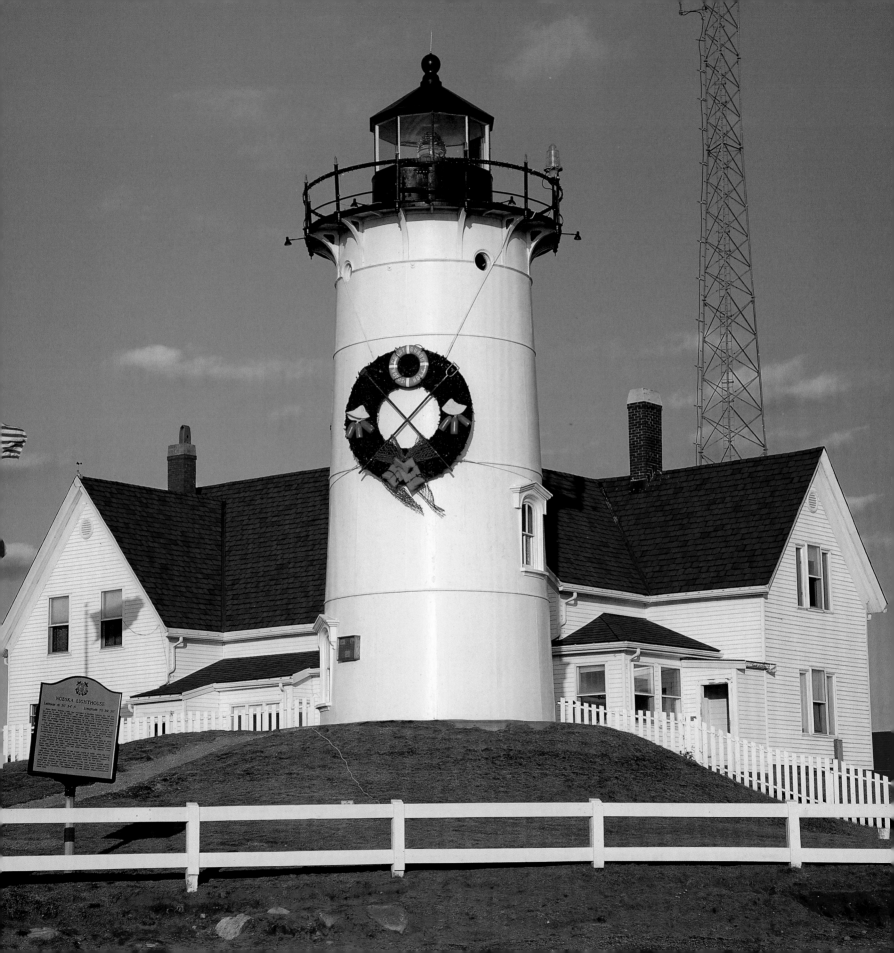

English settlers
founded Barnstable
in 1639. The harbor,
traditionally lined with
fishers' shacks and
oyster warehouses,
is now home to
artists' shops as well.
Potters and painters
cater to visitors who
wander the restored
sea captains' houses
and tour the cranberry
bogs and salt marshes.

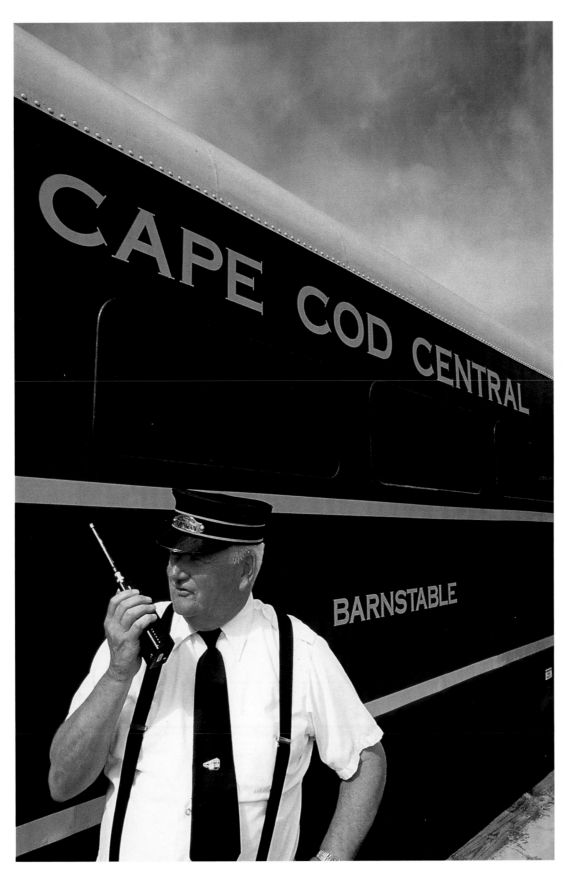

A conductor calls "all aboard" as this Cape Cod Central Railroad train prepares to depart. The railroad offers two-hour scenic tours and luxury dinner train excursions— journeys along the shores of the Cape and through time—to the region's last century, when passenger trains ran regularly along these tracks.

FACING PAGE–
This private retreat nestled along the shores near Barnstable is one of many that dot Cape Cod. Ever since the railway arrived in the mid-1800s, offering convenient access to the Cape's beaches, summer visitors have made this an annual destination. Presidents Ulysses S. Grant and Grover Cleveland were some of the earliest vacationers.

To John F. Kennedy, Cape Cod was a place to sail, connect with family, and relax with friends. Featuring interviews, a retrospective narrated by Walter Cronkite, and more than 80 photographs of the Kennedy family between 1934 and 1963, the John F. Kennedy Hyannis Museum commemorates the role of Cape Cod in the life of the president.

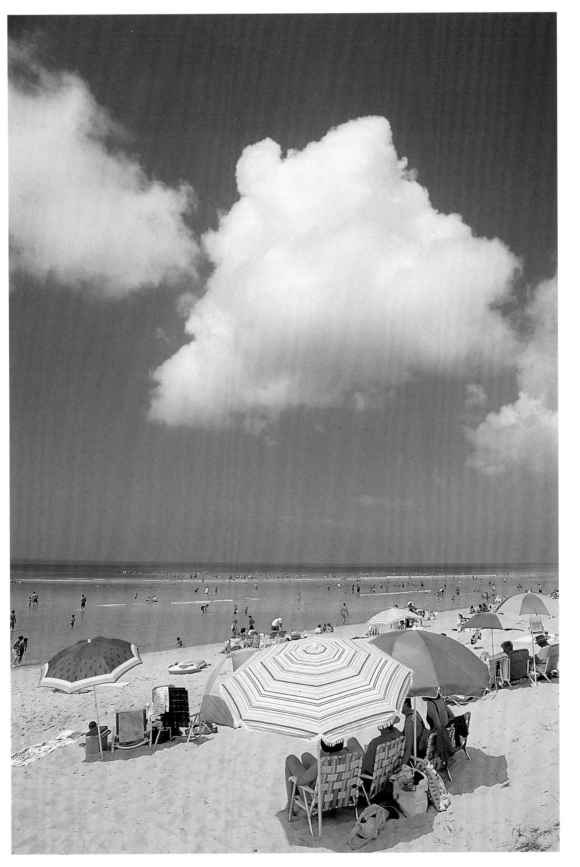

It's no surprise that Dennis is a favorite summer destination: eight beaches lie to the north on Cape Cod Bay; another eight lie along Nantucket Sound to the south. The board-walk from the street across the dunes of Mayflower Beach, pictured here, is just a few steps from town.

23

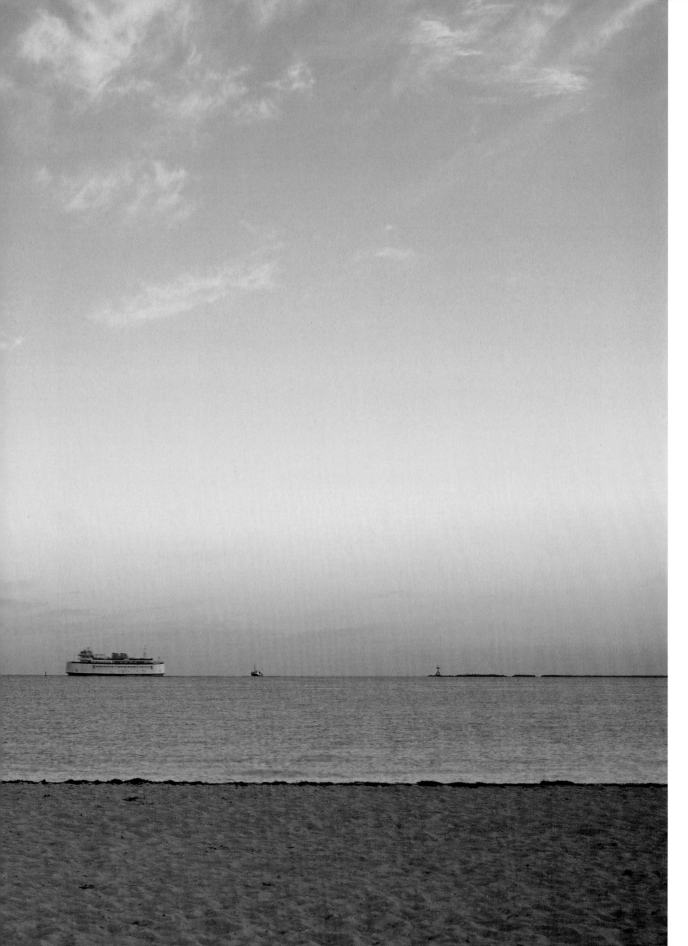

The port-side streets of Hyannis have long been home to ocean-goers—more than 200 shipmasters owned homes here in the early 1800s. Today, summer ferries run daily to Nantucket and Martha's Vineyard. Whale-watching cruises operate out of the harbor, docking alongside pleasure yachts and sport fishing vessels.

The community of Brewster is named for Mayflower passenger and early settler William Brewster. A local antique shop offers remnants of Cape Cod's past, from whale oil lamps and fishing nets to silver and china.

FACING PAGE—
Settler Thomas Prence built Brewster's first grist mill in 1663. In 1873, two years after the original was destroyed by fire, another was built on the site—Stony Brook Grist Mill, which still stands today. Summer visitors can tour the facilities and grind corn in the historic machinery.

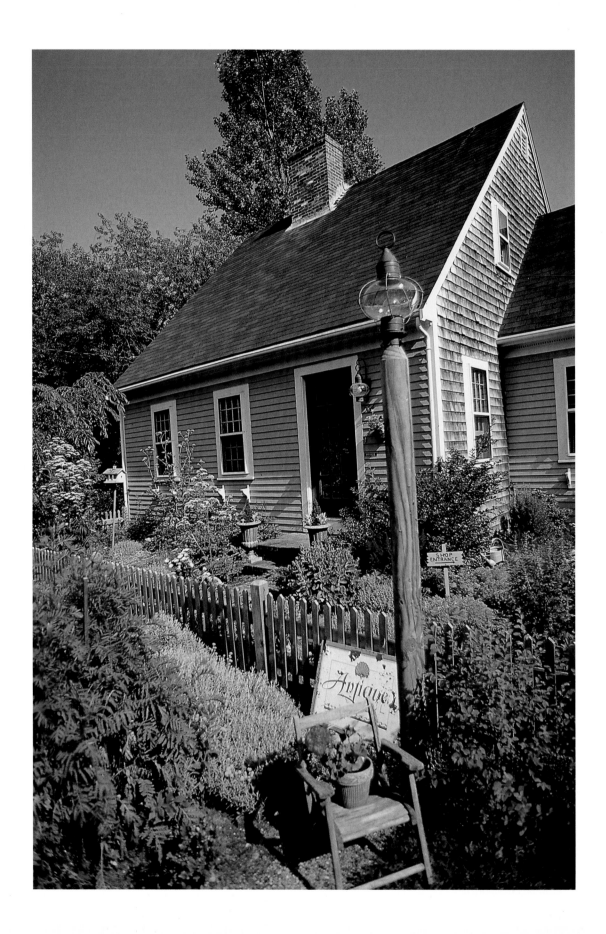

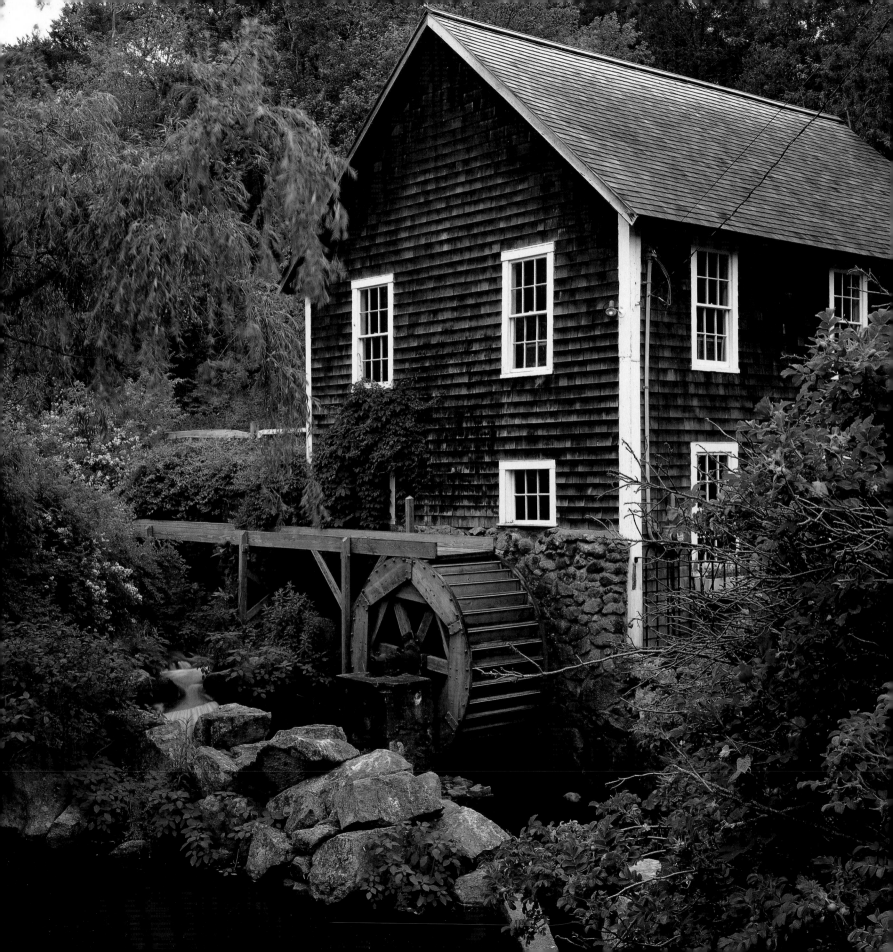

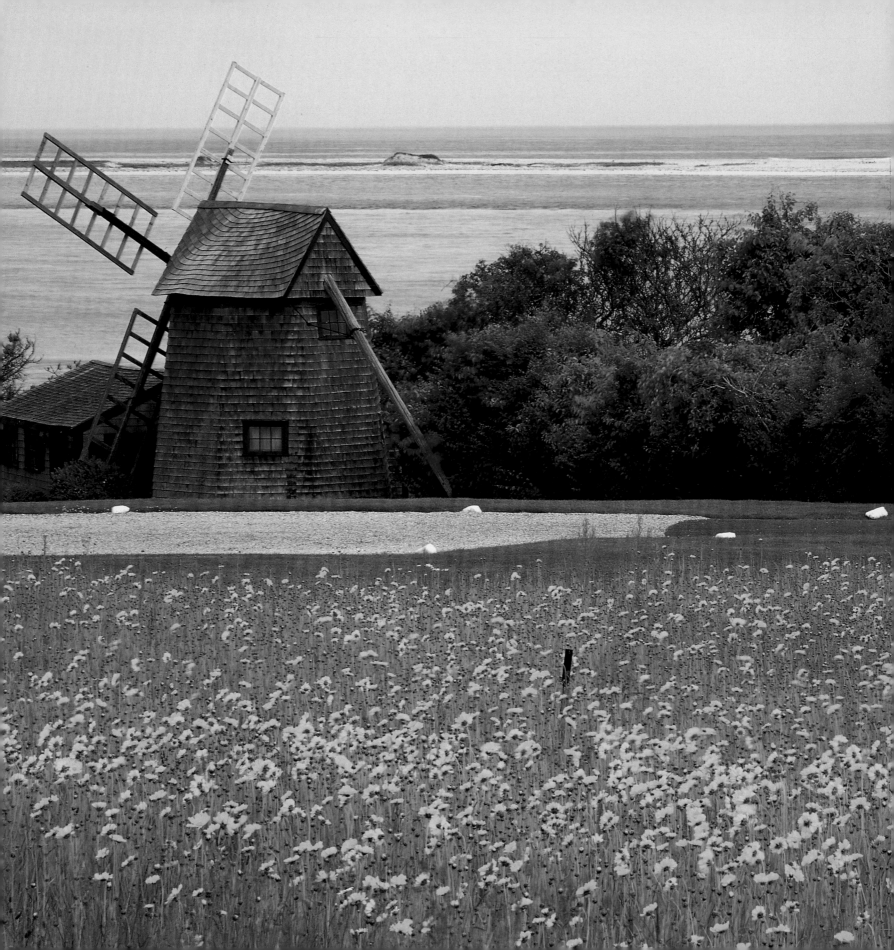

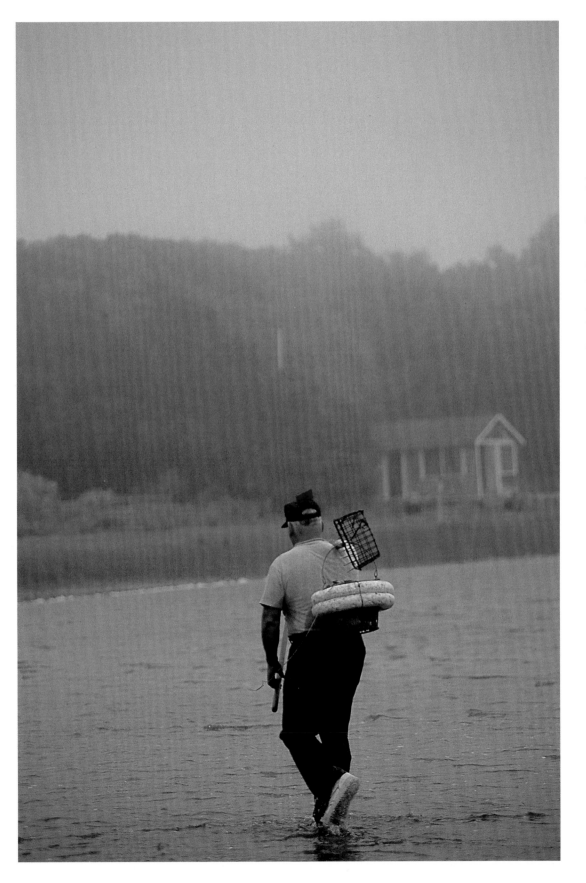

At low tide, clam diggers bend for hours over the sands of Cape Cod, some digging commercially and others looking for the main ingredient in a family chowder recipe. To comply with local laws, professional diggers dedicate some of their time to conservation— cleaning tidal flats or counting clam populations.

FACING PAGE—
Built by Benjamin Godfrey in 1797 and used commercially for almost a century, the Godfrey Grist Mill is still capable of grinding corn. Perched along Stage Harbor Road, the mill was damaged by storms in the 1900s, but the town of Chatham rescued the structure, moving it to Chase Park and using it to showcase this part of Cape Cod's history.

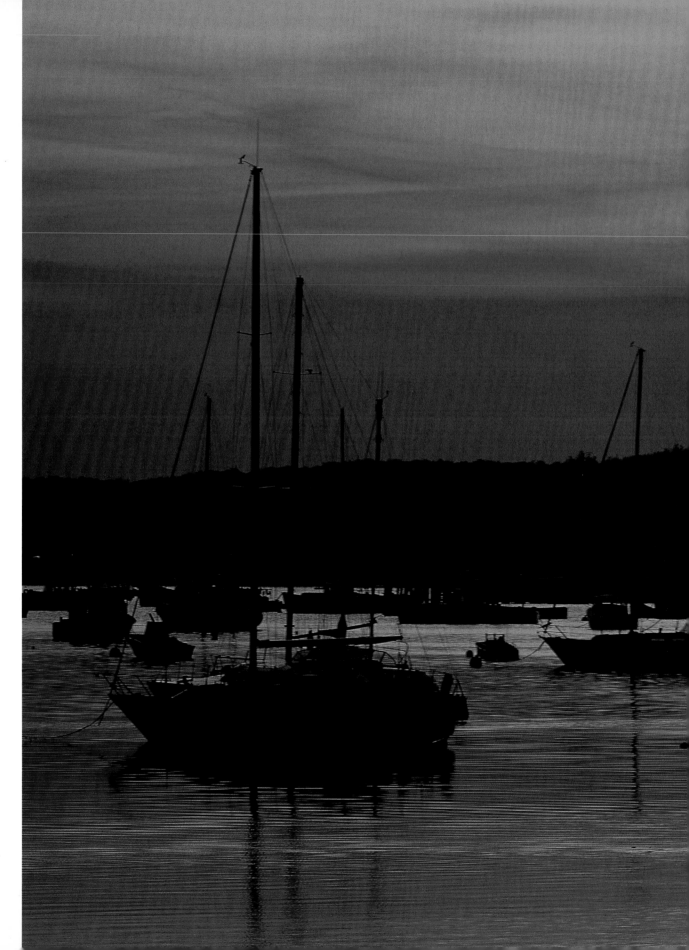

Birdwatchers and researchers have spotted more than 280 bird species within the 2,750-acre Monomoy National Wildlife Refuge. Seen here from Chatham's harbor, the preserve includes part of Morris Island as well as North and South Monomoy islands, accessible only by boat. Many of the birds that nest and summer here, including the rare piping plover, migrate south in the winter.

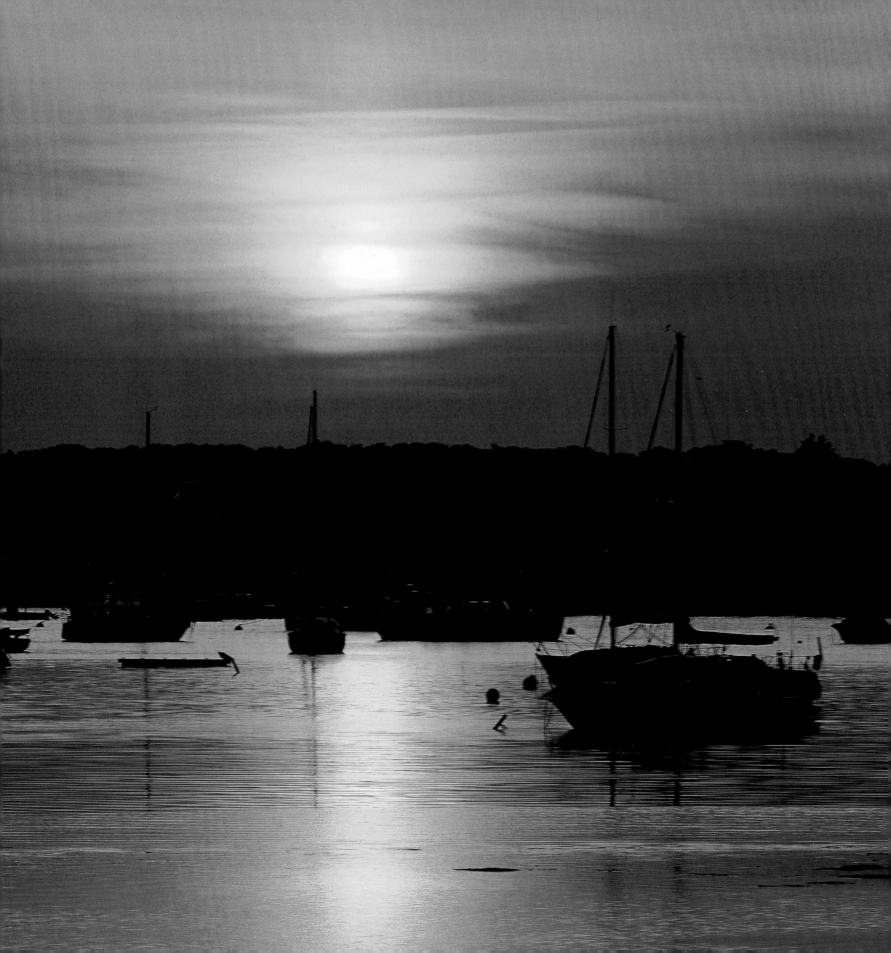

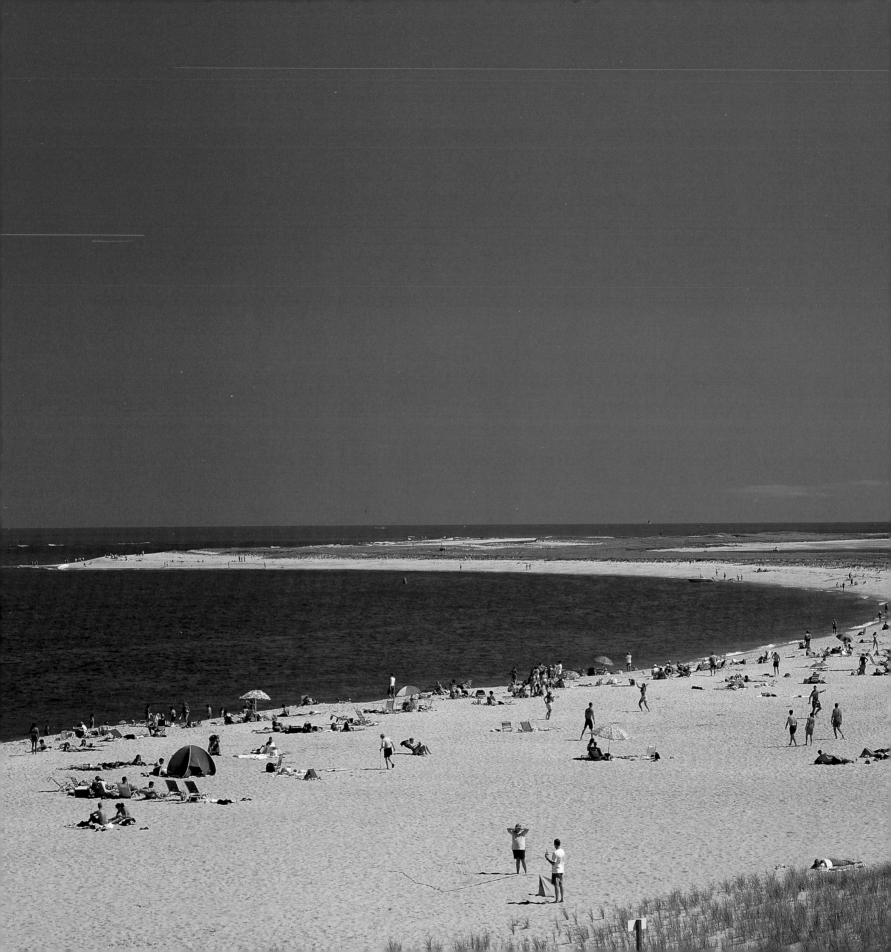

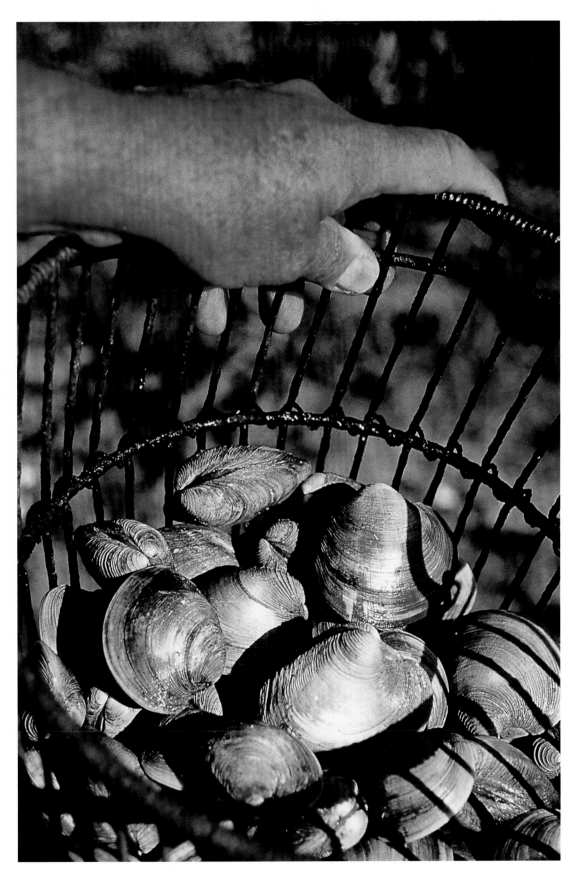

There are two ways to find cherrystones, also known as quahogs or littlenecks. Some rake the surface of the sand, turning up the shellfish just below. Others prefer to walk the beach in bare feet, feeling for slightly harder patches and digging for the shellfish by hand.

FACING PAGE—
Cape Cod boasts more than 150 fresh- and saltwater beaches. Some of the most popular surround the town of Chatham, where Nantucket Sound and the Atlantic buffet uncrowded sands. Those seeking true isolation choose the shores of North Beach, accessible only by boat.

Eastham was settled by the Pilgrims more than 350 years ago. Their small farms were followed by whaling and fishing enterprises, saltworks, and asparagus farms. Today the community is best known as a sunseekers' escape and a gateway to Cape Cod National Seashore.

FACING PAGE—
These herring gull eggs will hatch in 24 to 28 days. After about a month of care, the young birds will be ready to fend for themselves, scouring the shores for fish, dropping shellfish on the rocks to reveal the meat within, and following fishing boats in search of scraps.

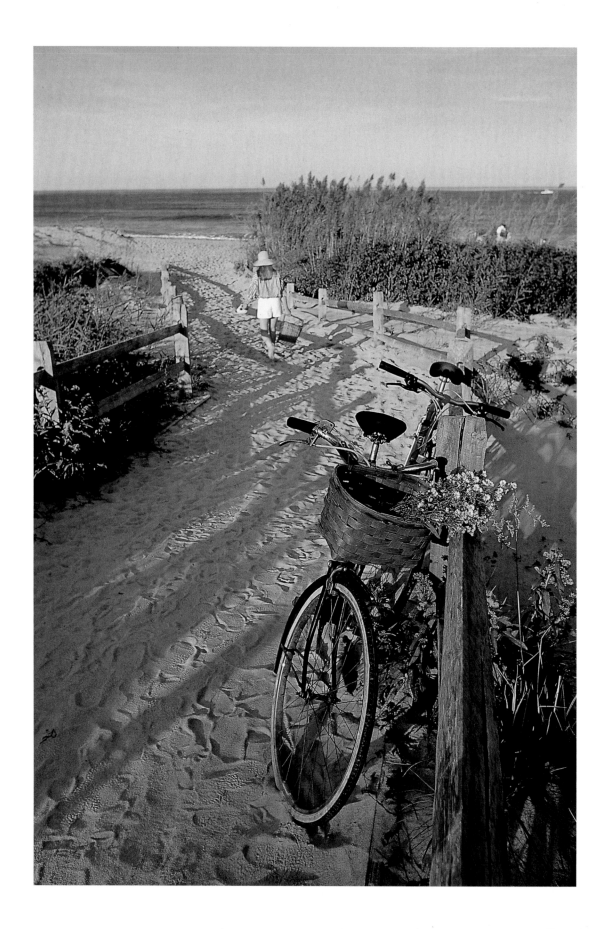

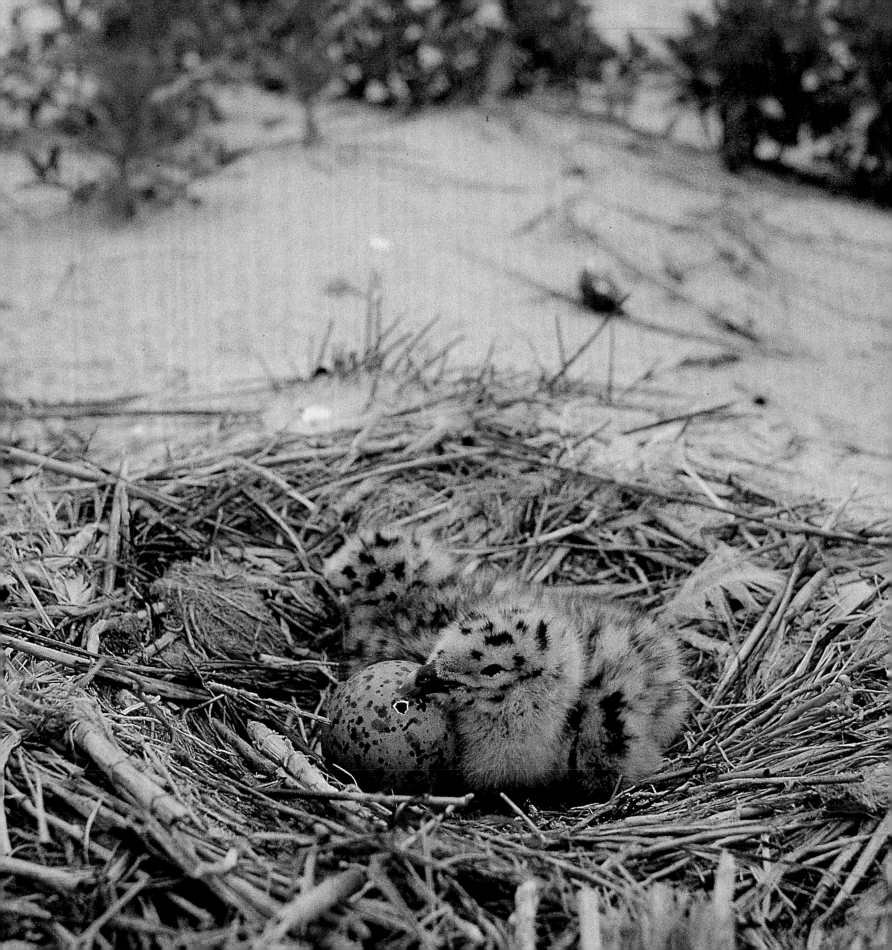

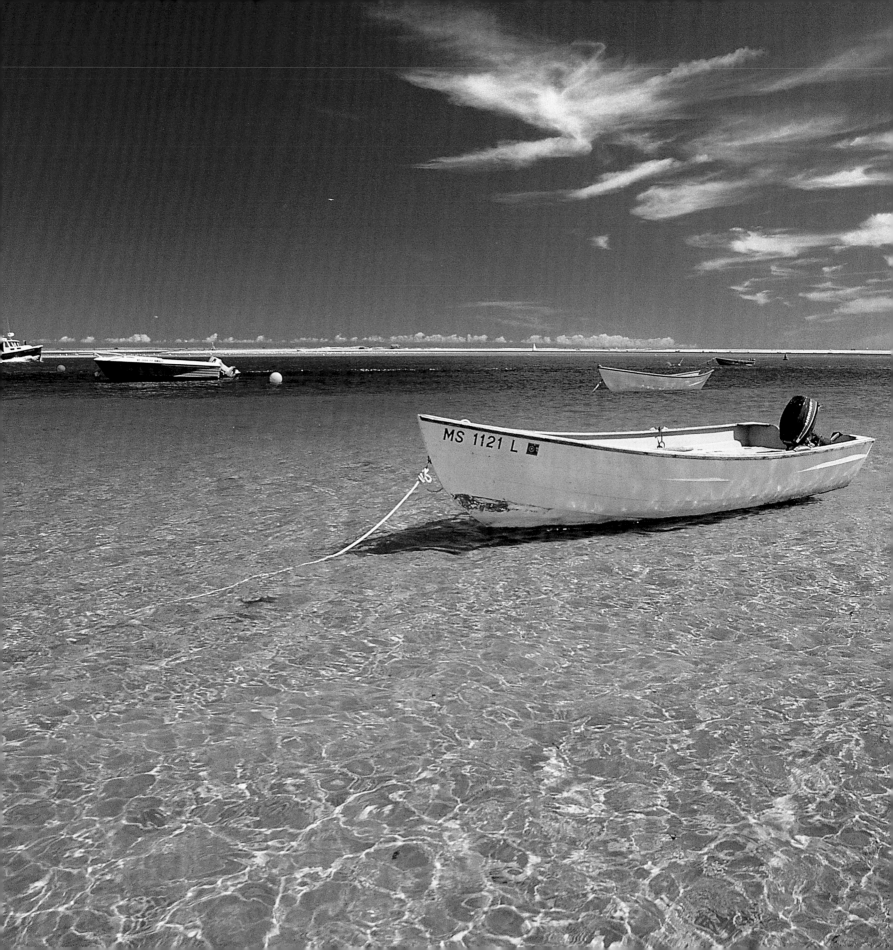

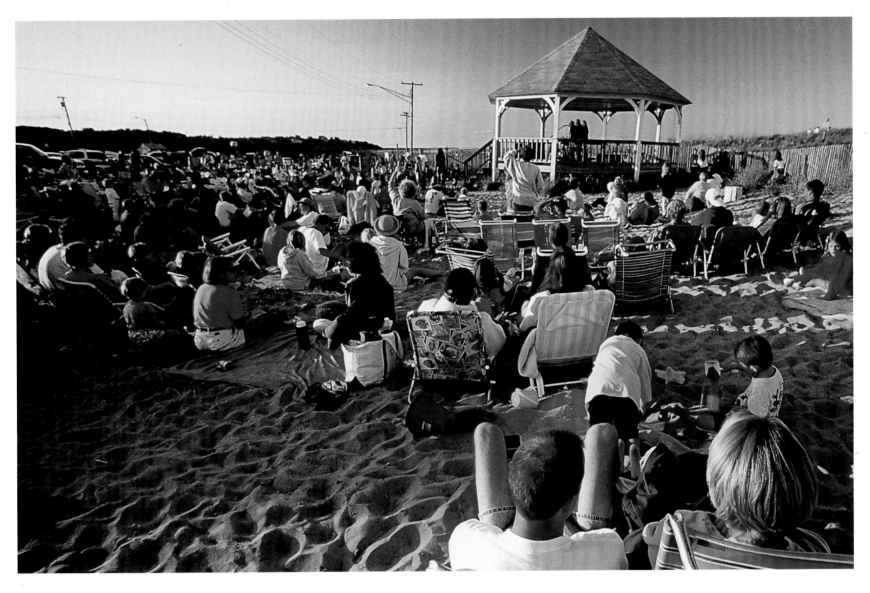

A crowd gathers for a free evening concert in Orleans. This town has a more tumultuous history than most. During the War of 1812, residents fought off British troops who wanted to destroy the local saltworks. War struck again in 1918, when a German submarine sank several barges off the coast.

In 1656, William Nickerson traded the local Sachem Mattaquason people a small boat for the land that is now Chatham. Nickerson was the first to settle the area known as the "first stop of the east wind."

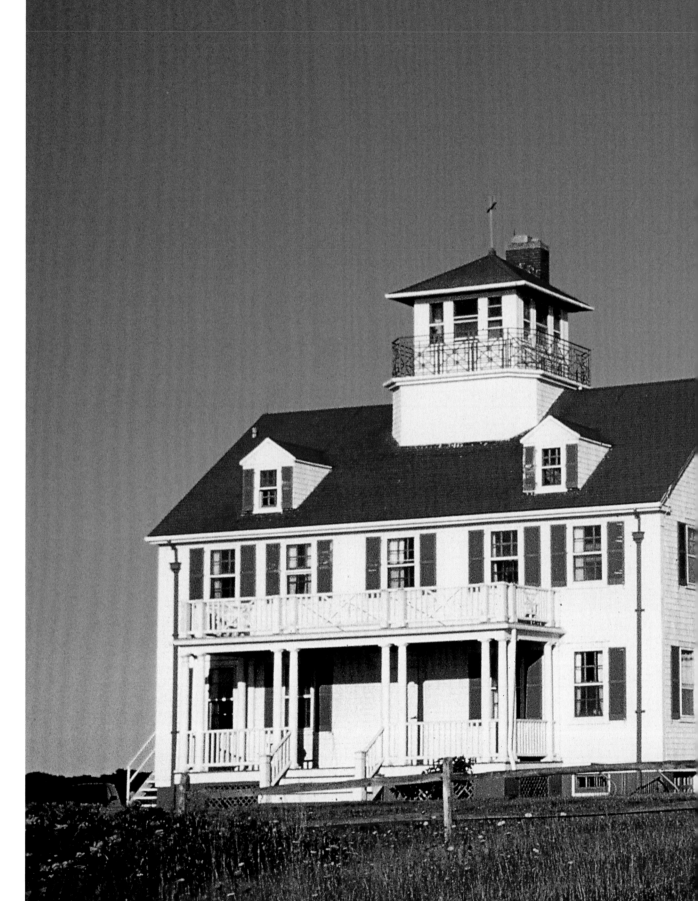

Eastham's beaches are popular with surfers as well as swimmers. Winds raise surf-perfect swells along the Atlantic year-round. When the summer tourists have disappeared, locals don their wetsuits and catch a few waves after work.

38

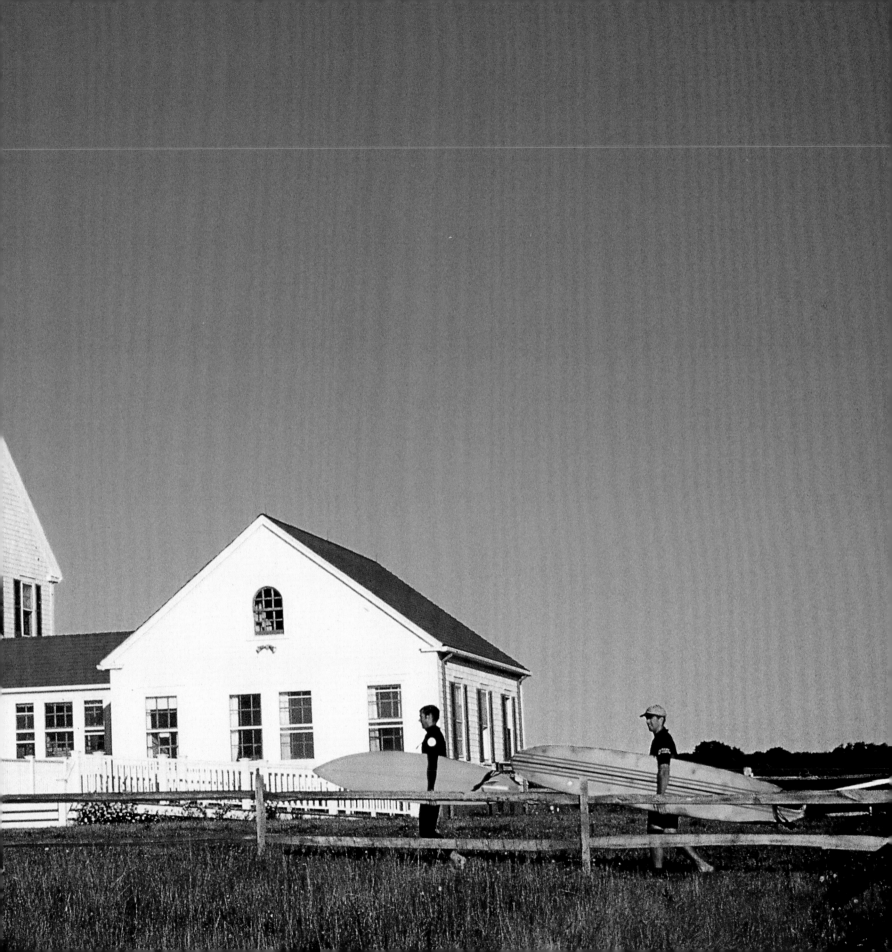

About 5 million people a year visit Cape Cod National Seashore, a 40-mile-long preserve on Cape Cod's Atlantic shore. The park highlights the diversity of the Cape's landscapes, from endless stretches of sand and rolling dunes to pine groves and saltwater marshes.

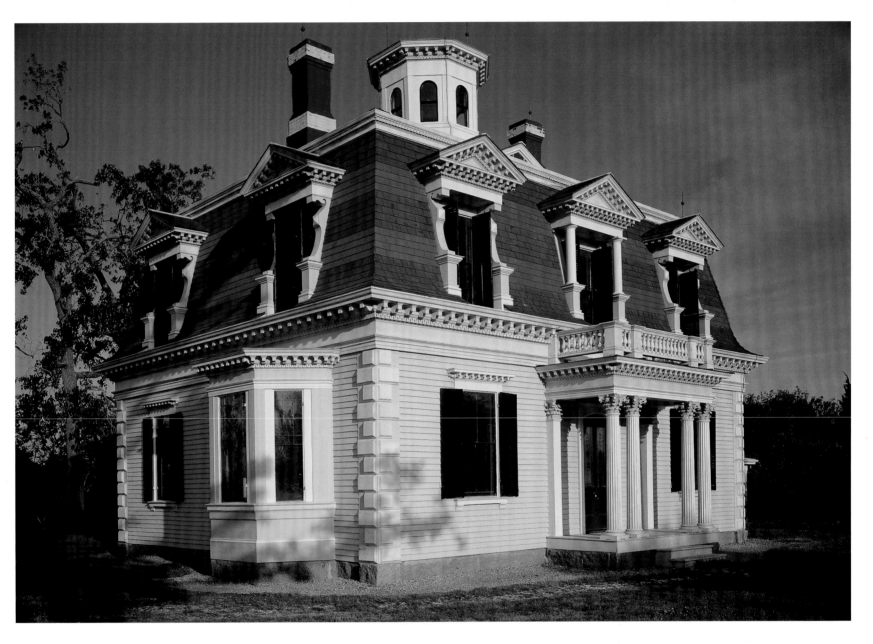

When President John F. Kennedy established Cape Cod National Park in 1961, it was the first preserve to include both pristine natural areas and residential neighborhoods. More than four decades later, hundreds of people, including residents of Wellfleet, Truro, and Provincetown, still live within park boundaries.

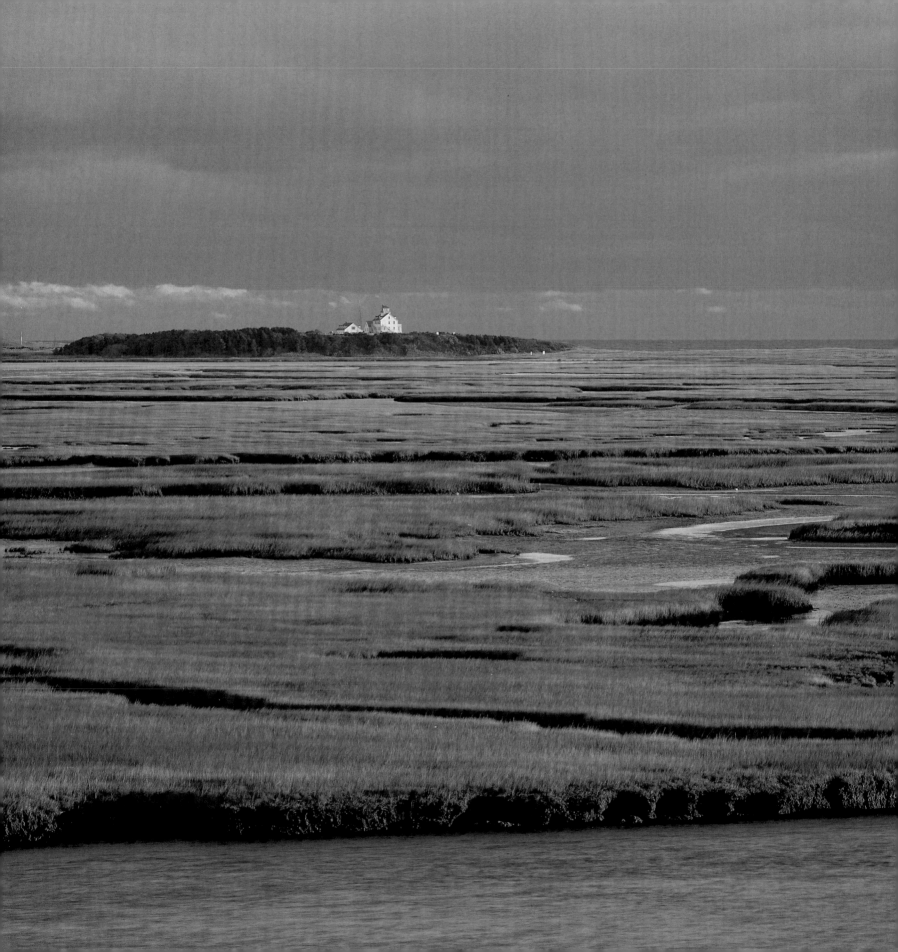

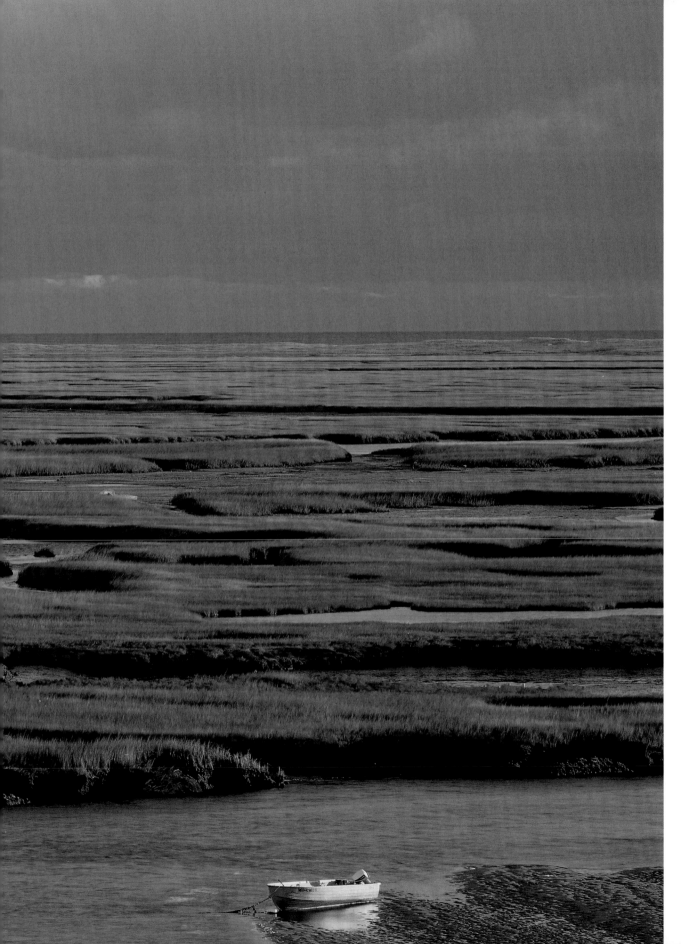

A former Coast Guard Station overlooks Nauset Marsh and Cape Cod National Seashore. Since the early 1800s, groups of volunteers kept watch over these waters, attempting to save shipwrecked sailors. The federal government established the US Life-Saving Service later in the century.

43

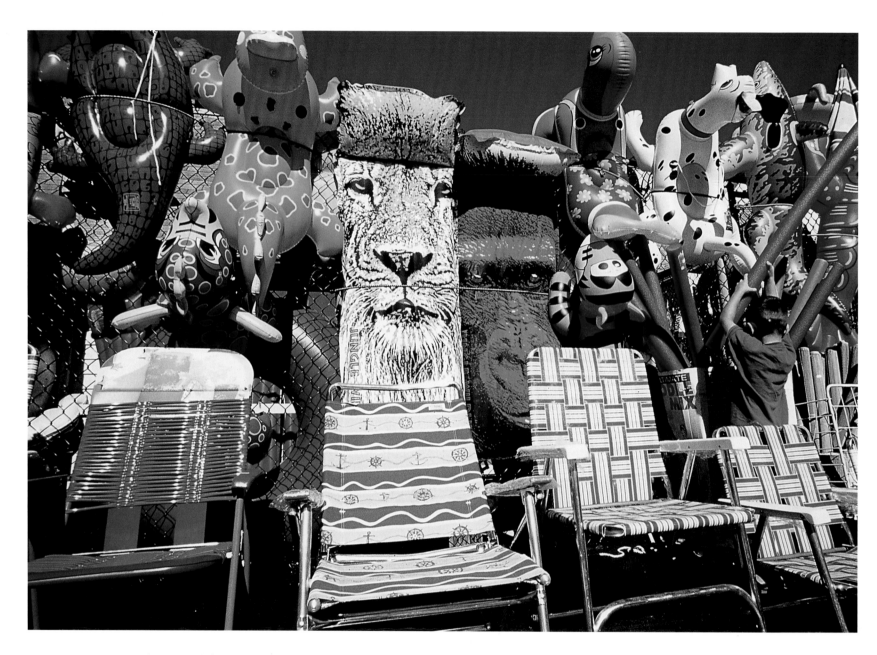

A souvenir stand in Wellfleet beckons sightseers with inflatable water toys and beach chairs. Along with the beaches that border the town, Wellfleet is known for its oysters, for its artists' shops and galleries, and for the nearby Wellfleet Bay Wildlife Sanctuary.

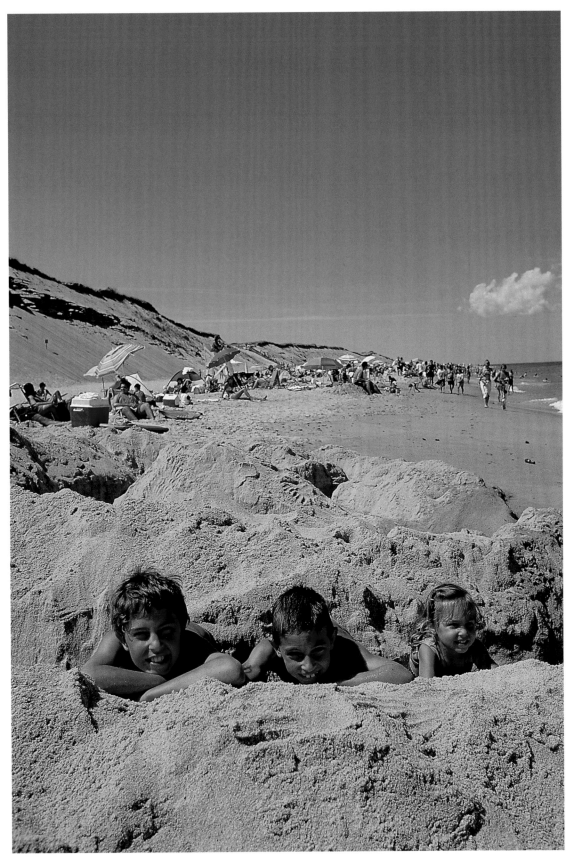

Marconi Beach, a crest of white sand along the Atlantic, lies near the site where Italian inventor Guglielmo Marconi built the first wireless station facing the Atlantic in 1903. Two years before, Marconi had successfully sent the first signal over the ocean. A reconstruction of his station and an observation tower now honor the inventor's achievements.

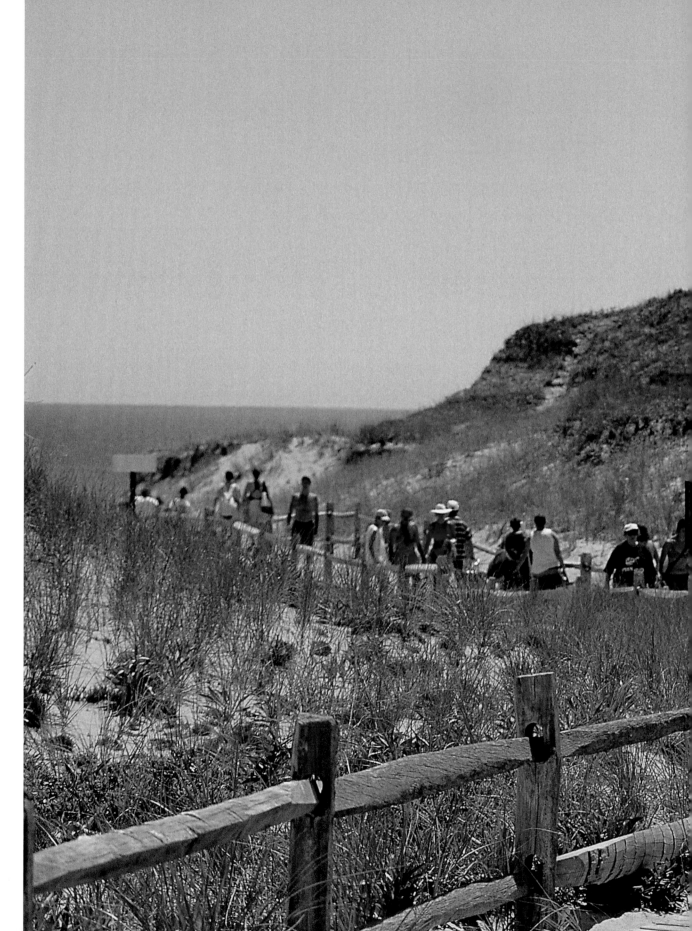

Marconi Beach is the administrative head-quarters of Cape Cod National Seashore. From here, rangers patrol the parklands, naturalists track the park's wildlife, and historians speak of the geographical and human past of the region.

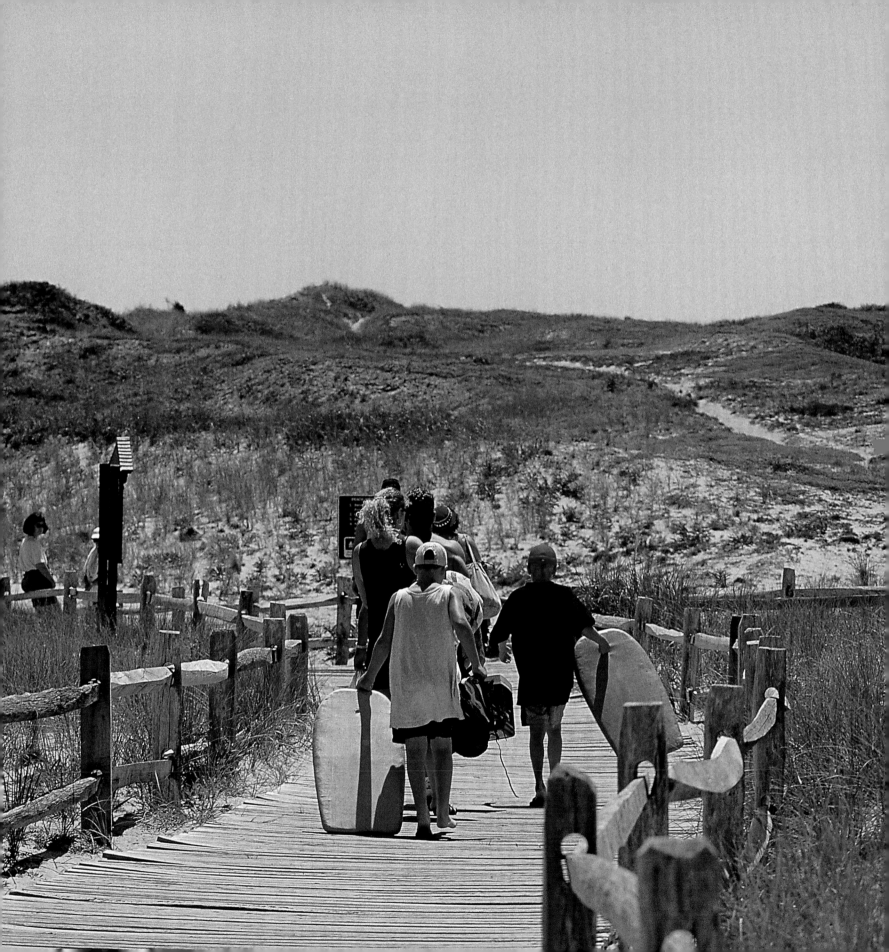

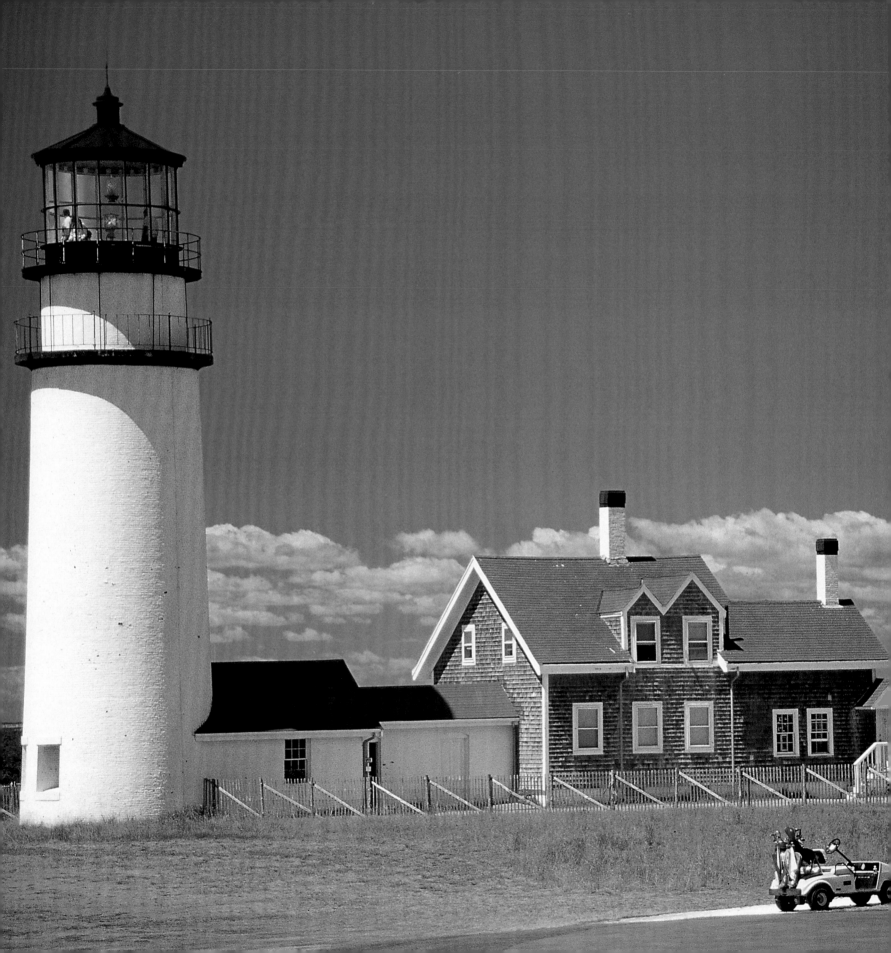

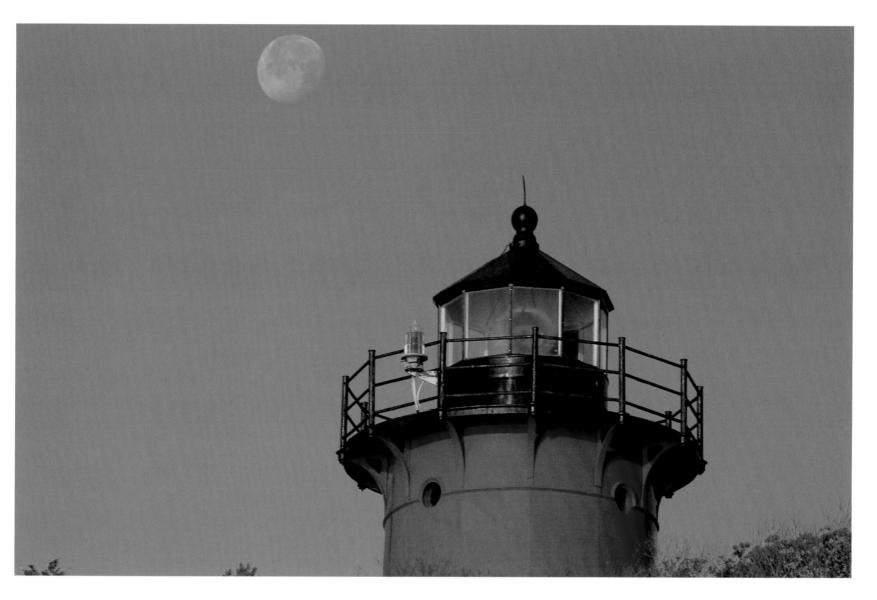

Storms battered the cliffs around Nauset Light for decades, tearing away the soil until only 37 feet remained between the beacon and the precipice. Local residents lobbied for the 1923 lighthouse to be saved and in 1996, it was moved 300 feet west, safely out of reach of the breakers.

Unique challenges face golfers at Highland Golf Links in North Truro. If they're not disturbed by the swift winds sweeping over the course, they may be distracted by a whale breaching offshore or by the panoramic views from the bluffs. One of the oldest golf clubs in the nation, Highland was established in 1892.

Only 30 percent of the pine barrens that once covered Massachusetts survive today, and environmentalists struggle to protect the barrens that remain on Cape Cod. These rich habitats of pitch pine and scrub oak host a wealth of life, including eastern box turtles and whip-poor-wills.

50

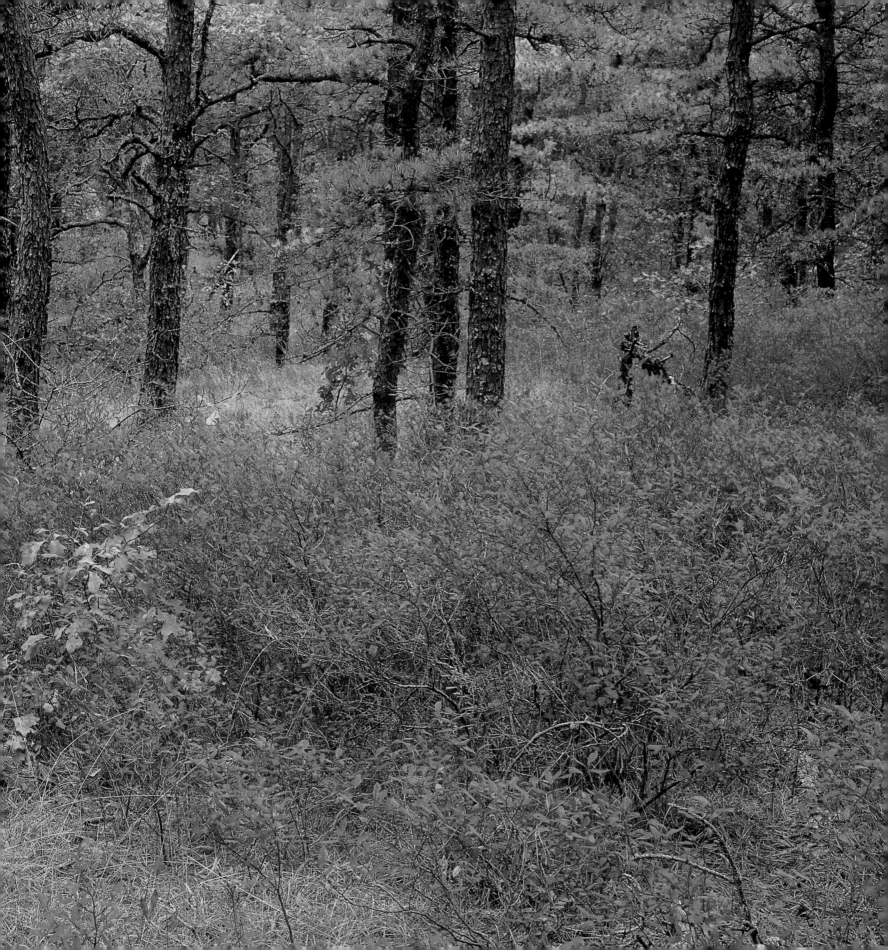

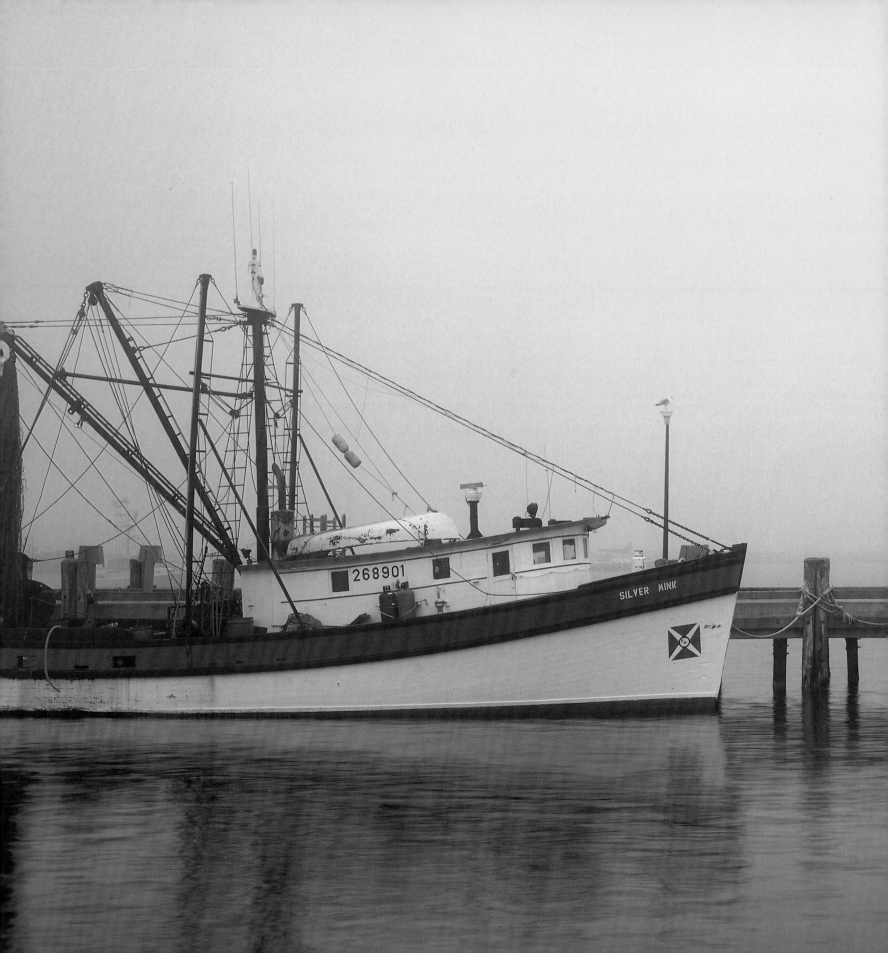

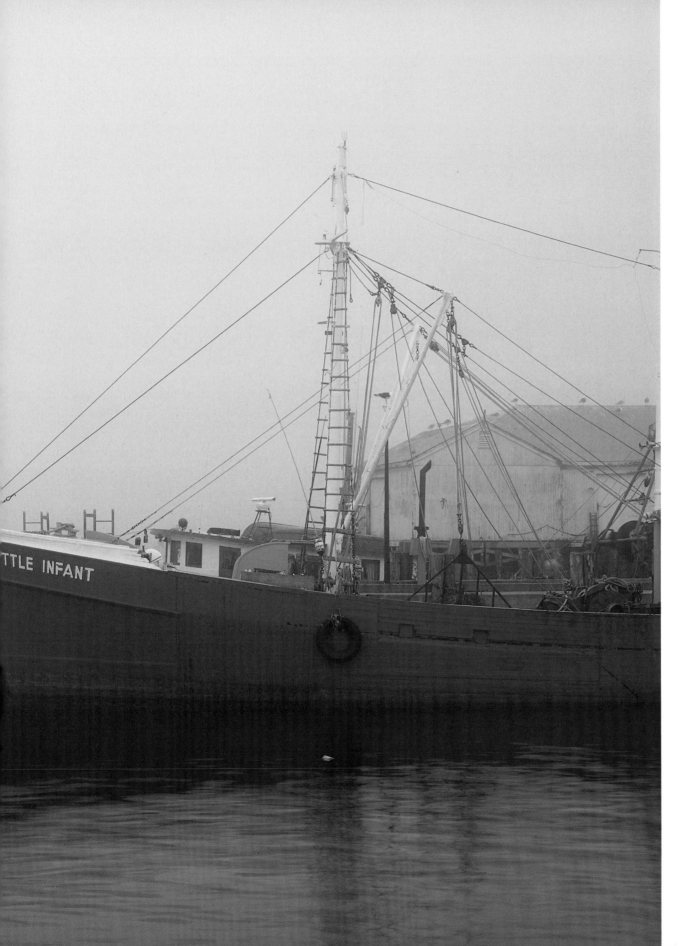

The Pilgrims stopped in Provincetown in 1620, before moving on to Plymouth. This protected harbor then became a base for commercial fishing and whaling. When the whalers finally left in the early 1900s, Provincetown was reborn as an artists' community and vacation destination.

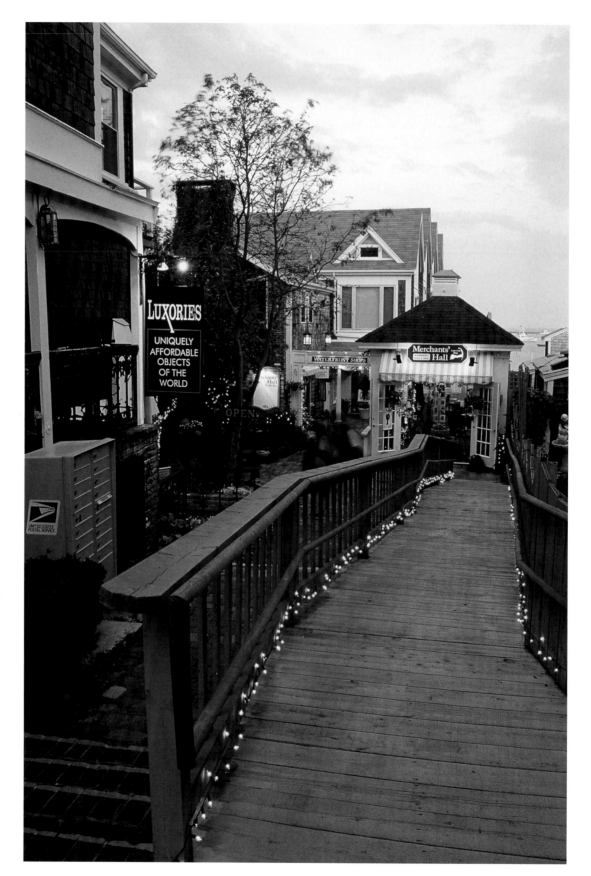

Home to about 4,000 people (who know it as "P-town"), Provincetown booms each summer, hosting up to 30,000 visitors. More than 100 inns and guesthouses cater to these arrivals, while downtown shops, eateries, and bars offer some of the Cape's most lively nightlife.

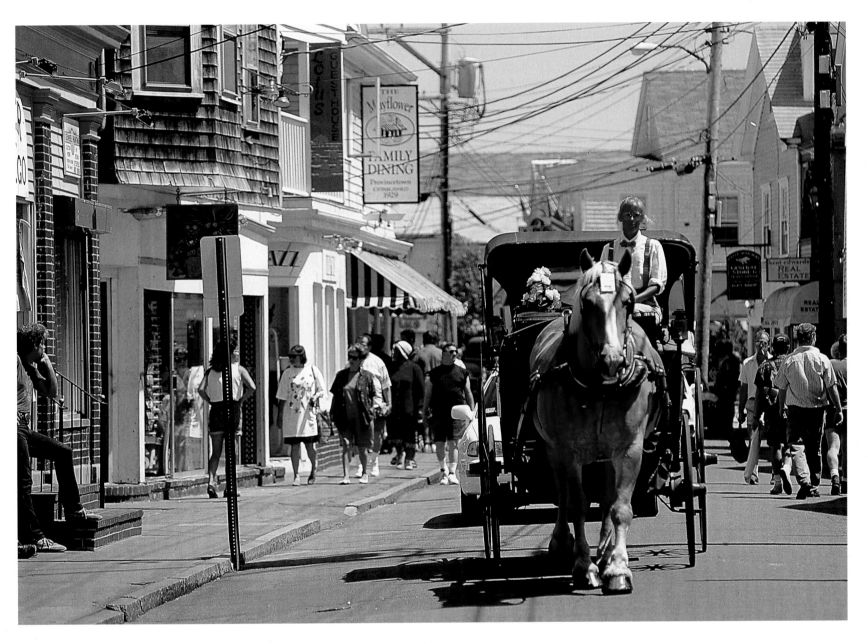

Portuguese fishermen were some of the first to permanently settle in Provincetown. Their legacy remains on Commercial Street, where Portuguese bakeries offer breads, pastries, and sweets to passersby.

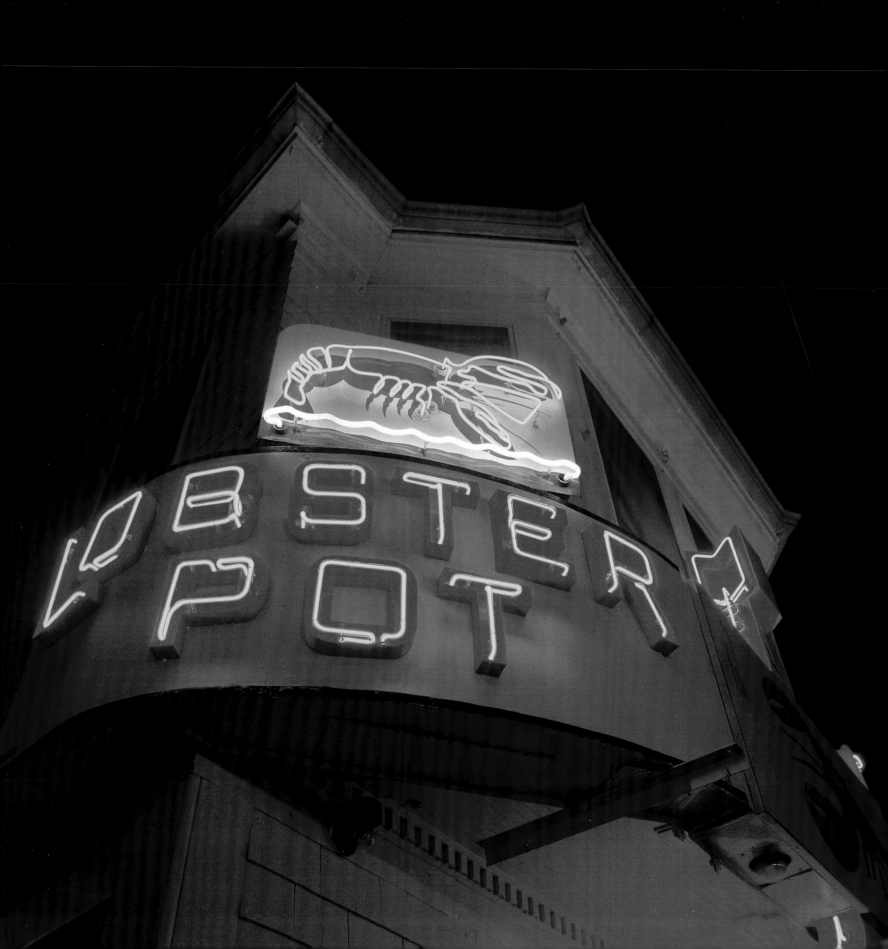

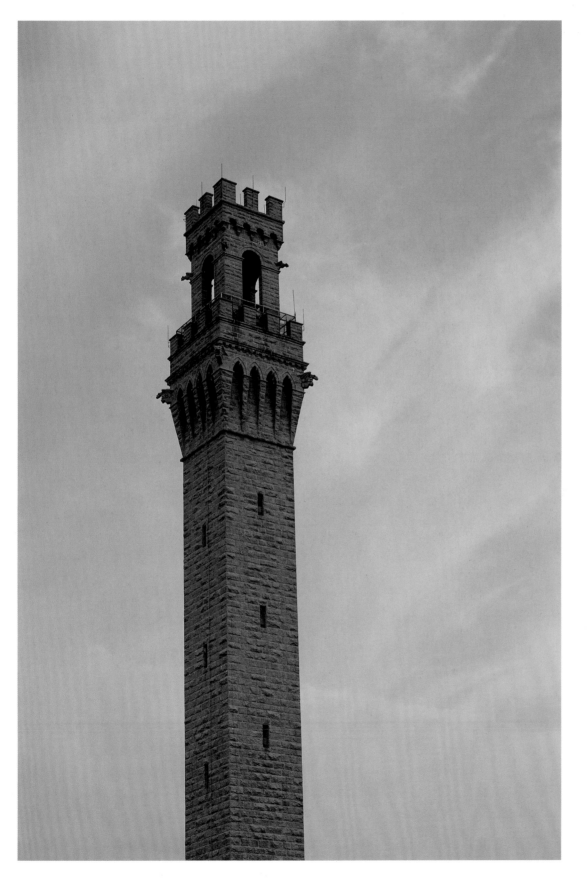

President Theodore Roosevelt laid the cornerstone of the Pilgrim Monument on August 20, 1907. The tallest granite structure in America—252 feet high— the monument was built by the Cape Cod Pilgrim Memorial Association to honor the arrival of the Pilgrims in 1620. Visitors can climb 116 stairs and 60 ramps to the top.

FACING PAGE—
International eateries and contemporary bistros stand side-by-side with traditional lobster restaurants on Provincetown's streets. At the Lobster Pot, patrons enjoy harbor views while dining on fresh local seafood, steaks, and famous clam chowder.

There was no permanent settlement at Provincetown before the arrival of Europeans. The Wampanoag native people traveled here in summer months to fish the bountiful harbor. Viking ships are believed to have charted the waters, and pirates used the region's bays and coves as temporary hideouts.

FACING PAGE—
Abundant in the waters of Cape Cod, lobster used to be the food of the poor, disdained by the wealthy and left for the servants. That all changed in the mid-1800s, when the world discovered a taste for lobster meat and New England fishers began trapping the creatures, and canning and selling the rich meat.

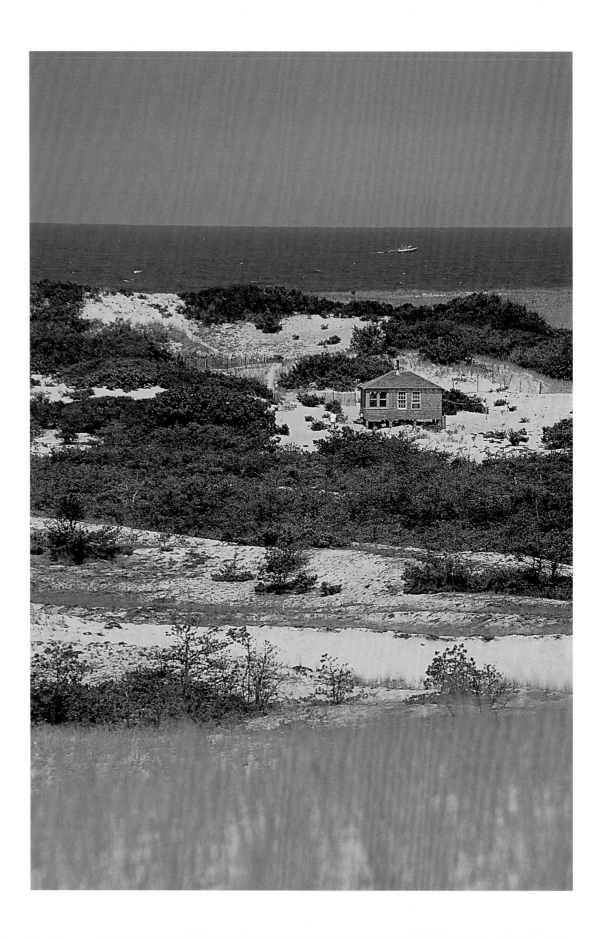

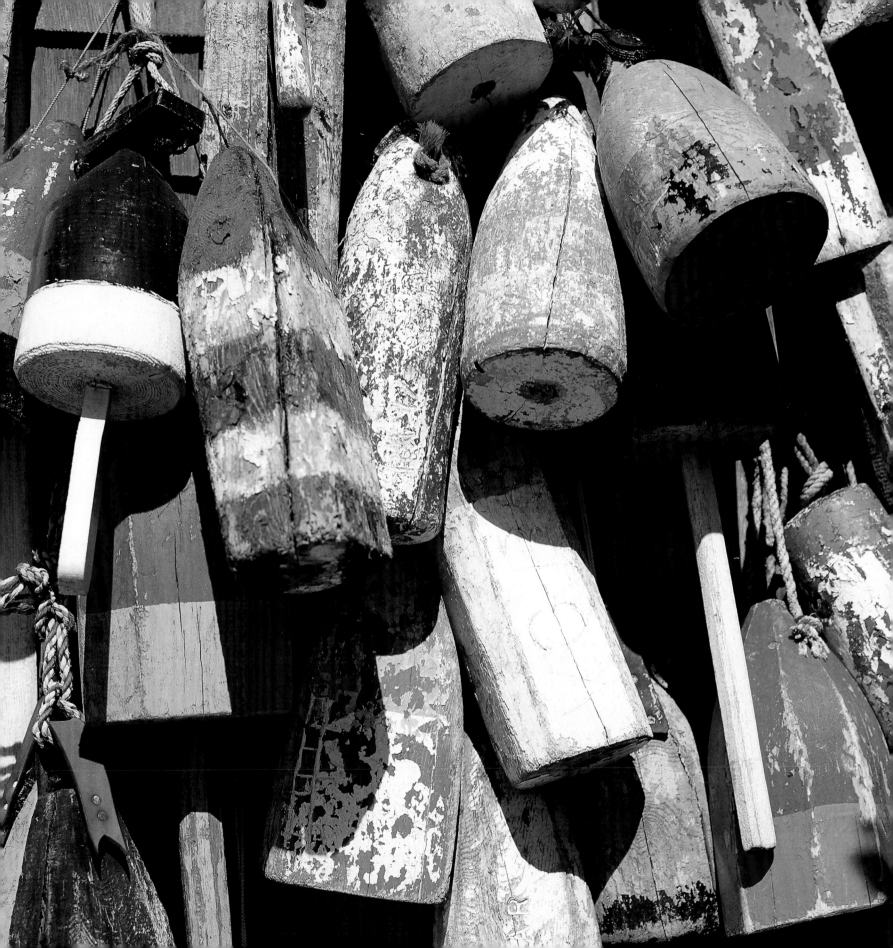

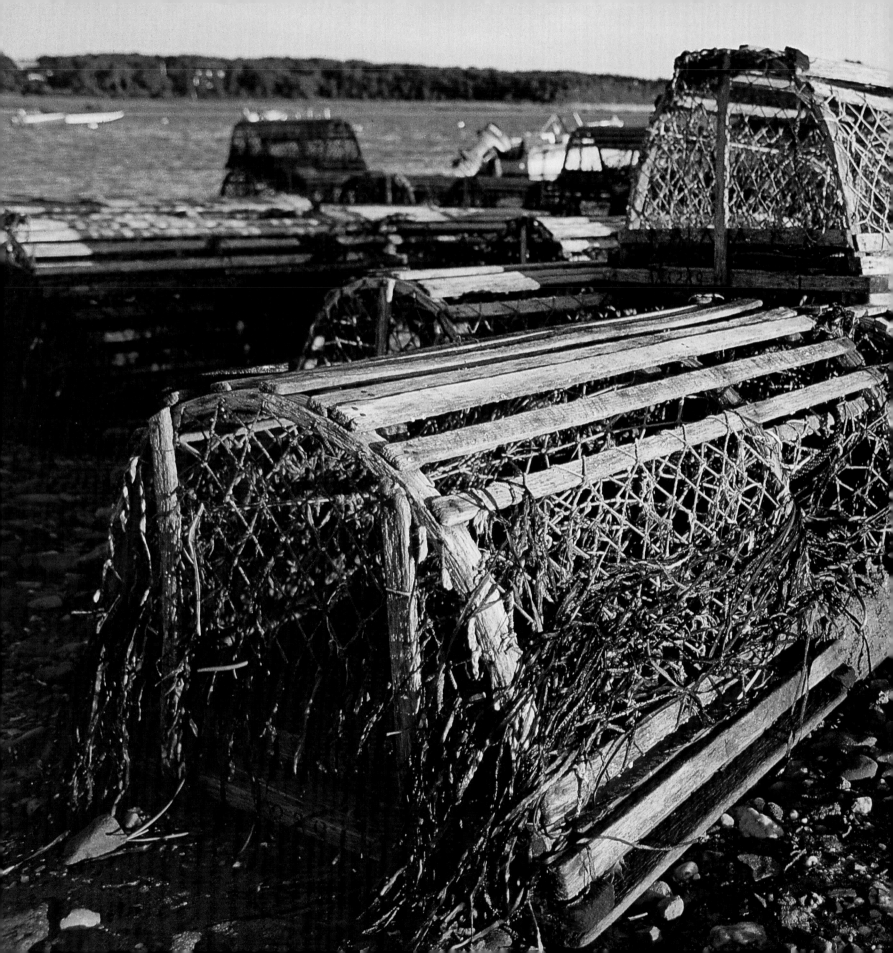

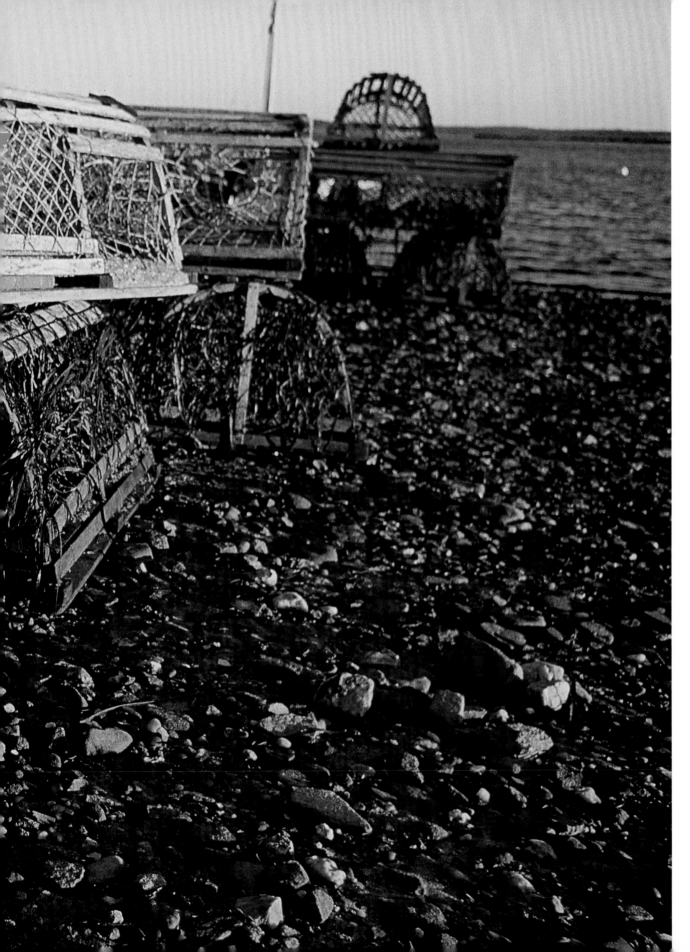

Many of Cape Cod's annual events and festivals celebrate the region's seafaring history. At Cape Cod Maritime Days each May, visitors can explore local lighthouses, watch a screening of *Moby Dick*, dance to east coast music, or wander arts and crafts fairs.

61

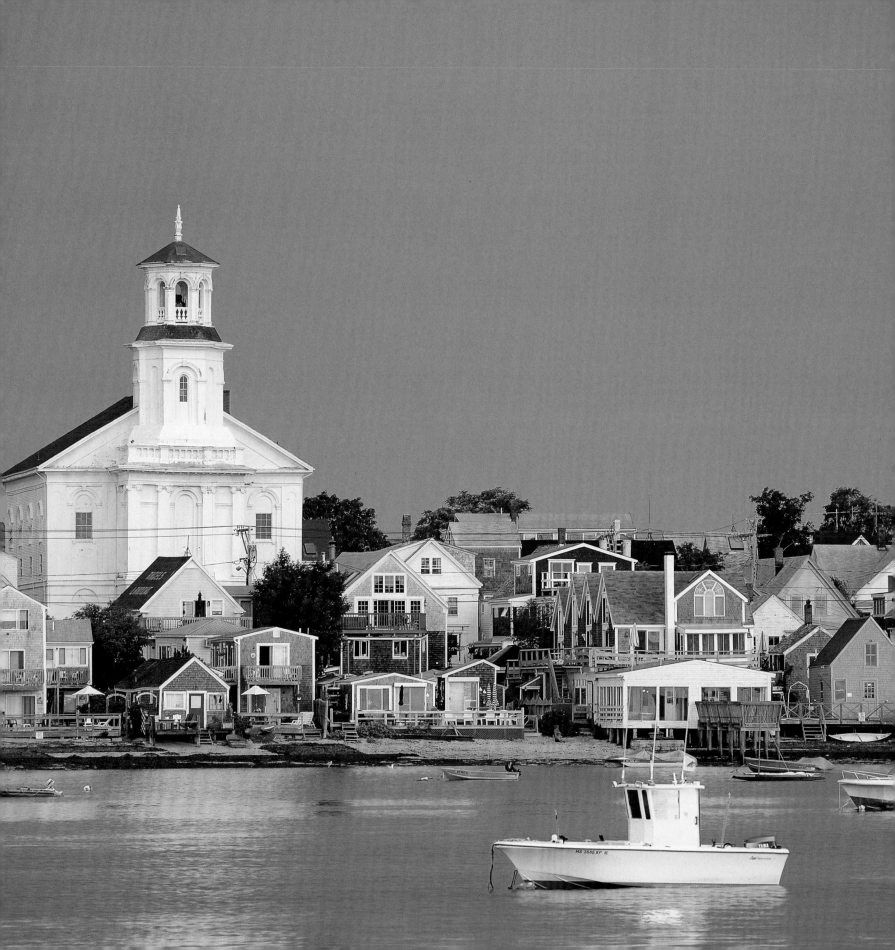

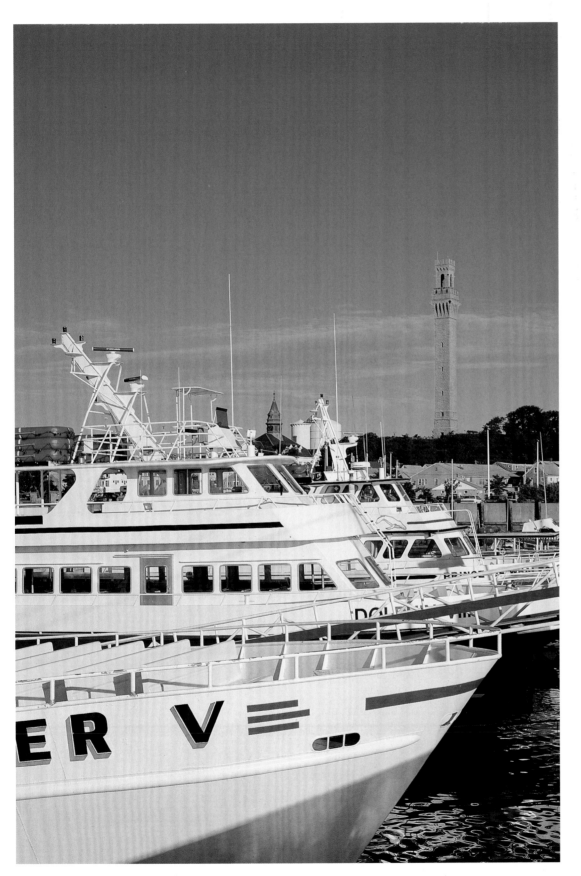

While a few commercial fishing boats still dock in the harbor, most of the vessels are now trolling for tourists, offering charter fishing and whale-watching cruises. The largest whale-watching fleet on the east coast operates from Provincetown.

FACING PAGE—
In its nineteenth-century heyday, Provincetown was home to 5,000 residents and a fleet of 700 fishing vessels. More than 50 wharves lined the harbor and prosperous captains' and merchants' homes crowded Commercial Street. Seventy windmills along the shore churned sea water into vats, where the water evaporated, producing salt.

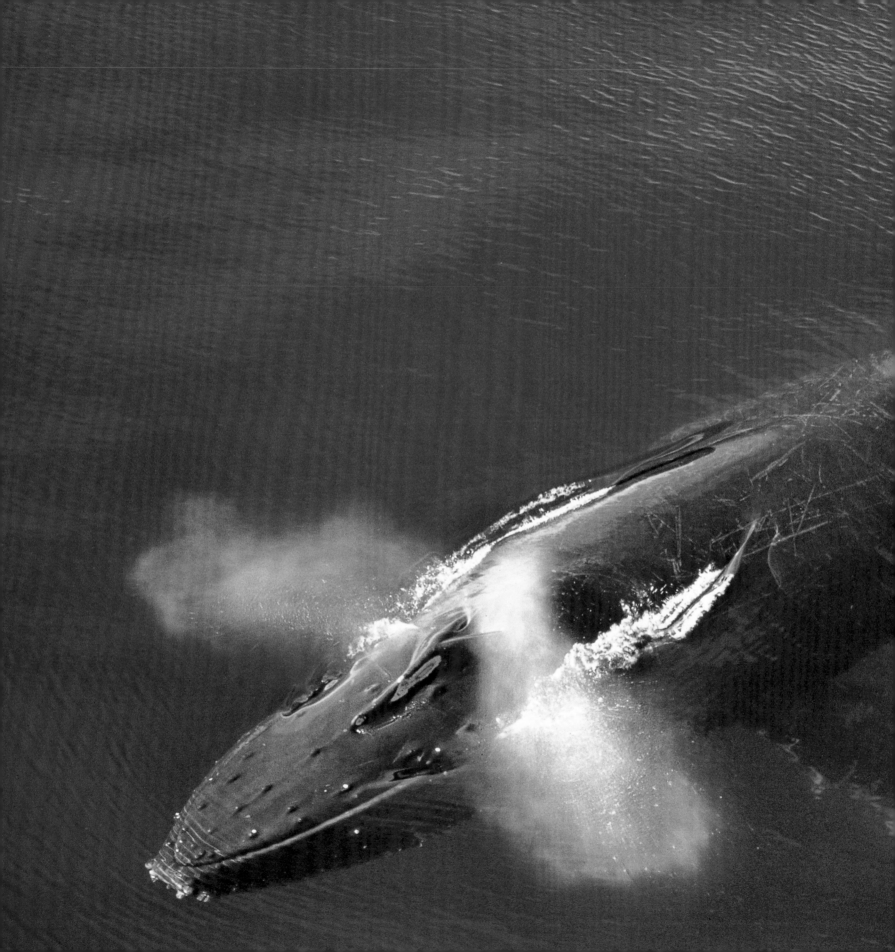

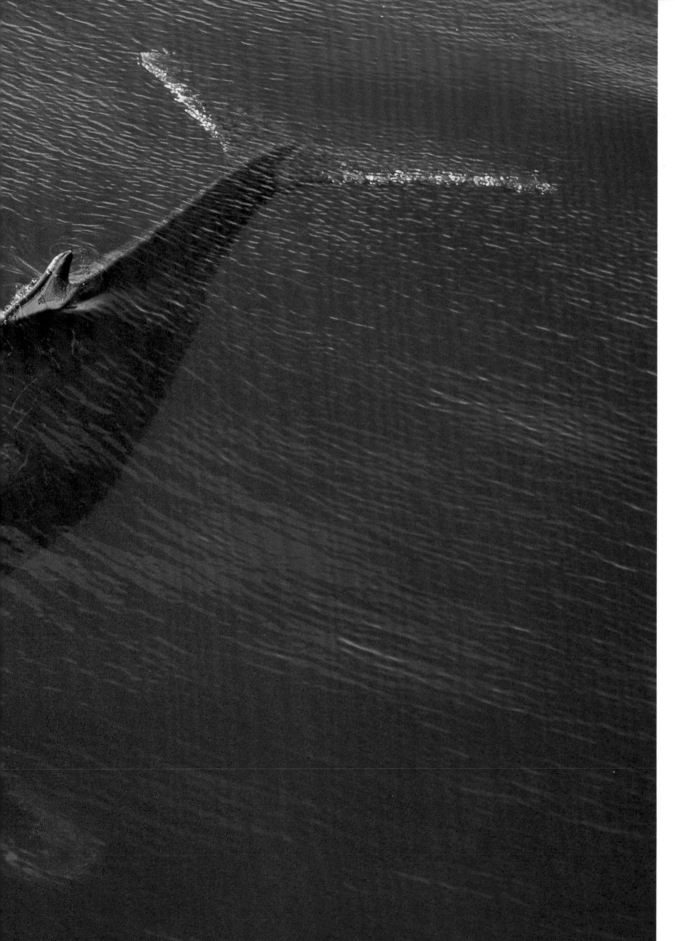

Humpback, finback,
right, and minke
whales are some of
the most commonly
spotted from the bow
of a Cape Cod whale-
watching vessel.
Humpbacks retreat
to warmer Caribbean
waters to breed and
calve each winter,
but they're back in
Cape Cod for spring,
summer, and fall,
often breaching
close to shore.

English explorer Bartholomew Gosnold sailed the *Concord* along the Atlantic coast of the New World in 1602. He named Cape Cod for the fish teeming in the waters and christened Martha's Vineyard for his daughter Martha and the island's profusion of wild grapes.

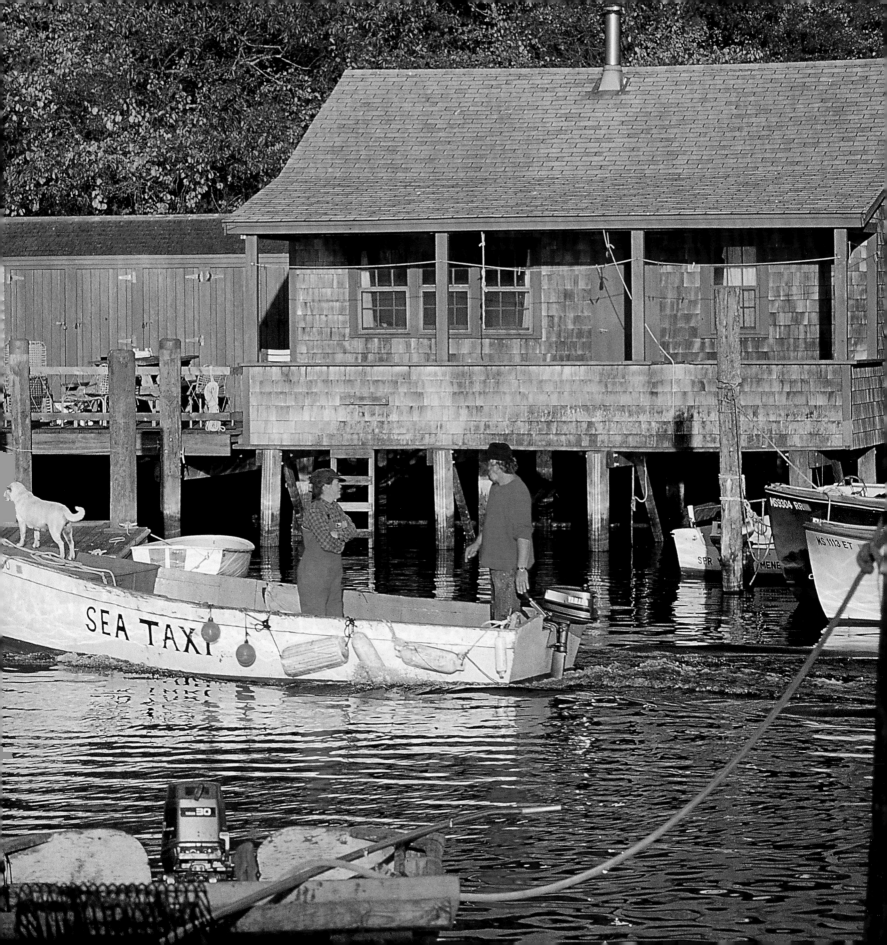

Though commercial fishing has declined in the last few decades, the trawlers that leave Cape Cod harbors each morning still support a host of secondary businesses— packers, wholesalers, and suppliers.

FACING PAGE— Cape Cod National Seashore encompasses most of Provincetown as well as the beaches and dunes nearby. Cyclists can explore trails through the hills while hikers can choose some of the park's guided excursions.

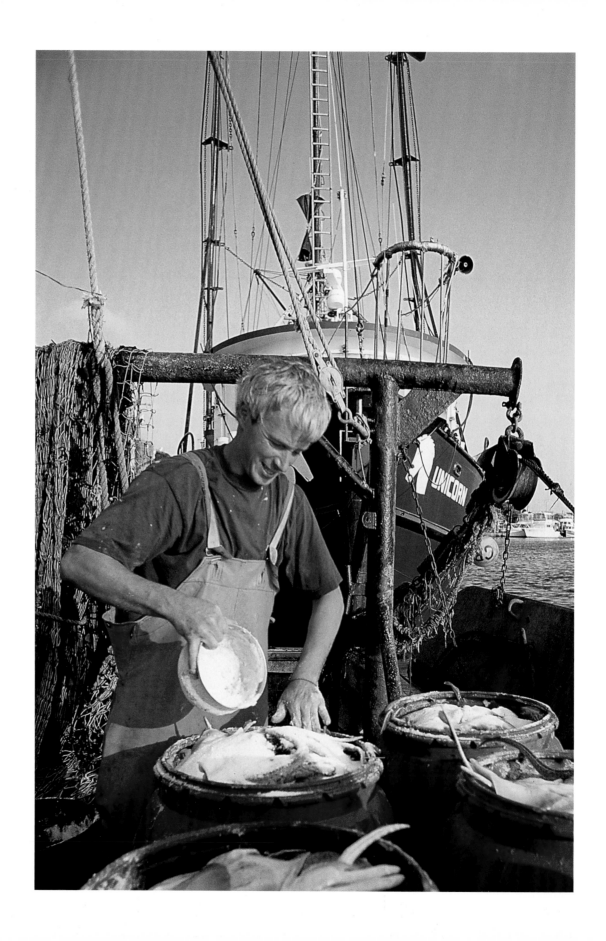

The sea constantly batters the 150-foot-high Aquinnah Cliffs at the southwestern tip of Martha's Vineyard. The Wampanoag people who live near the cliffs are the descendants of natives who helped the first Europeans settle here centuries ago. Known for their bravery, Wampanoag men steered some of the first whaling ships and rescued countless shipwrecked sailors.

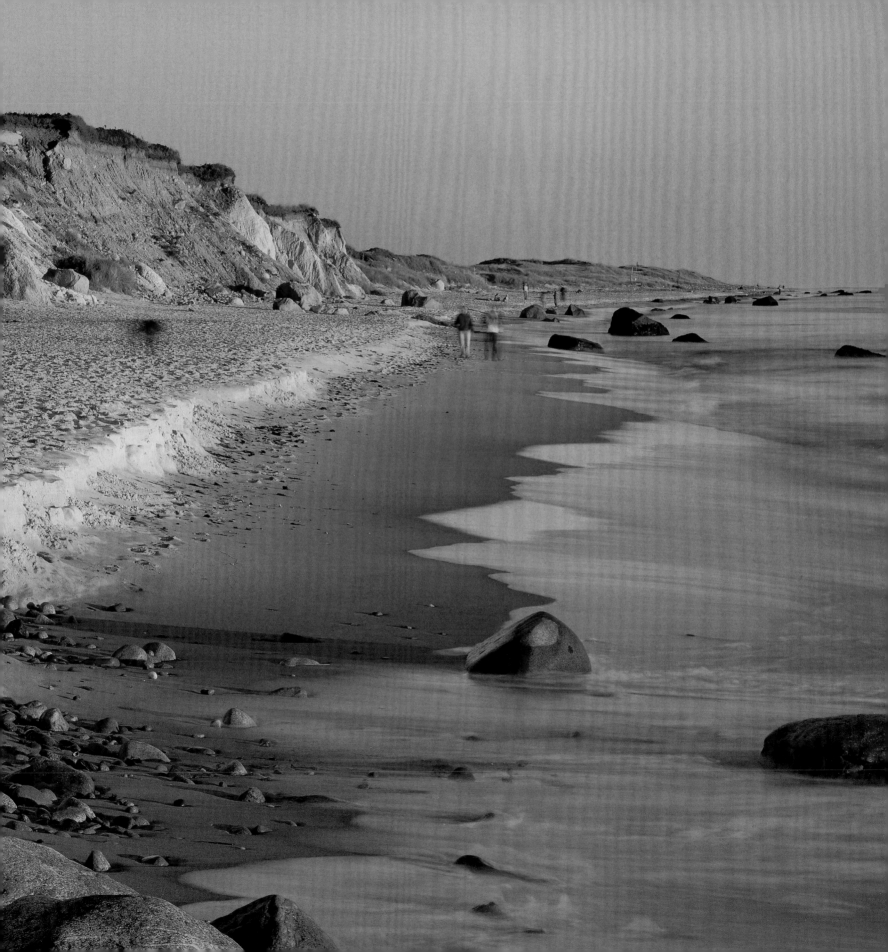

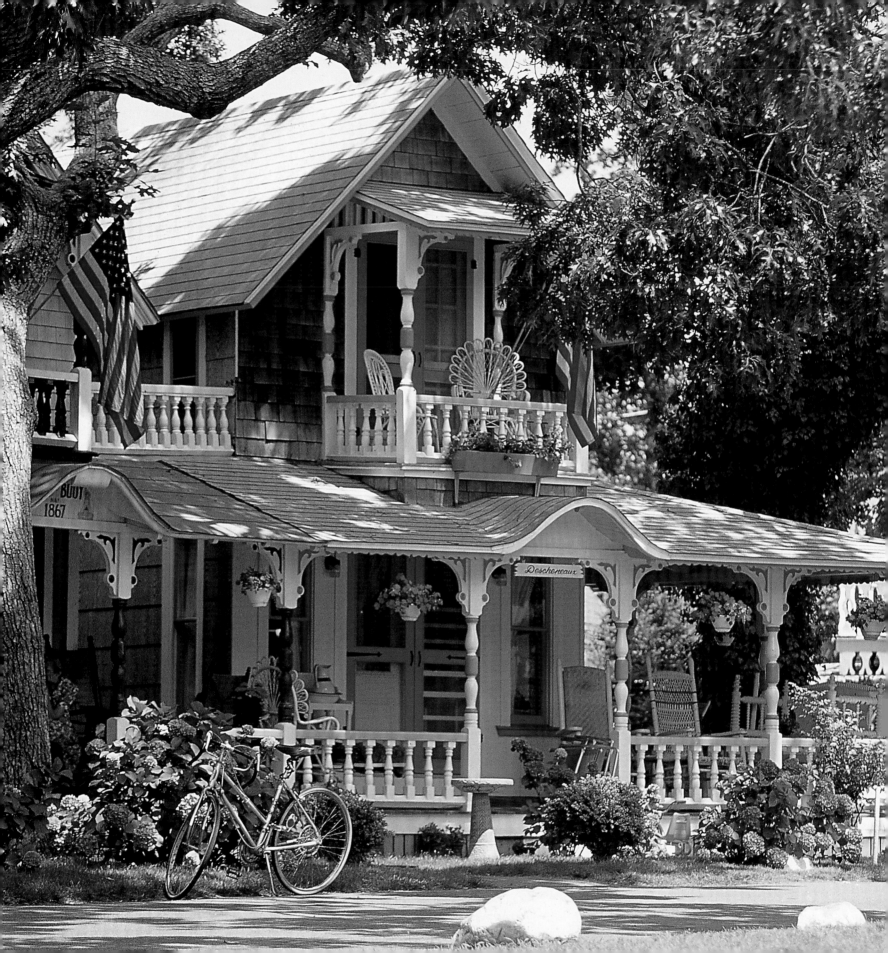

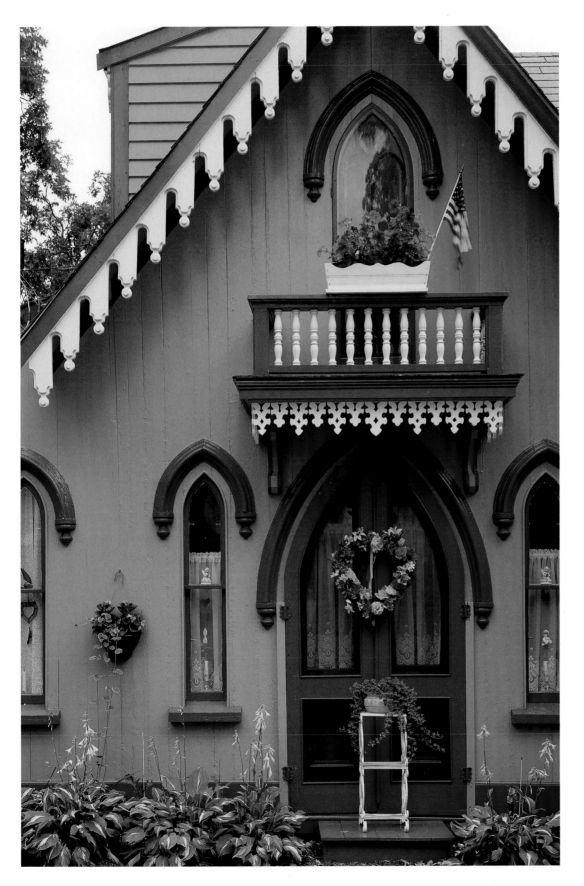

The revivalists decorated their Oak Bluffs cottages with elaborate window shutters and eaves, carved railings, and colorful paint. The "gingerbread" style was eventually copied by the island's wealthier residents, and some of the most ornate homes still stand today.

FACING PAGE–
In 1835, Jeremiah Pease organized the first summer church meeting near what is now the town of Oak Bluffs. A few tents soon turned into mass revival meetings. Cottages sprang up around the revival grounds—so many that the community was first called Cottagetown.

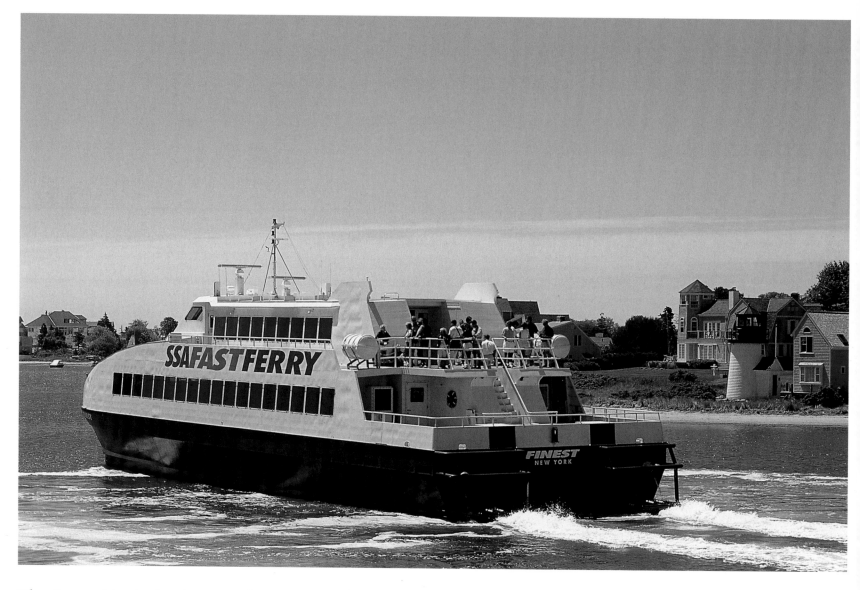

The Steamship Authority provides year-round vehicle and passenger ferry service to Martha's Vineyard and Nantucket, but Nantucket visitors are encouraged to leave their cars behind. Most of the island's attractions and beaches are served by local shuttles.

Connected to the shore by a thin strip of land, the Edgartown Lighthouse was built in 1938 in Ipswich and brought to Martha's Vineyard by raft. It replaced an earlier structure that had stood on the island for more than a century.

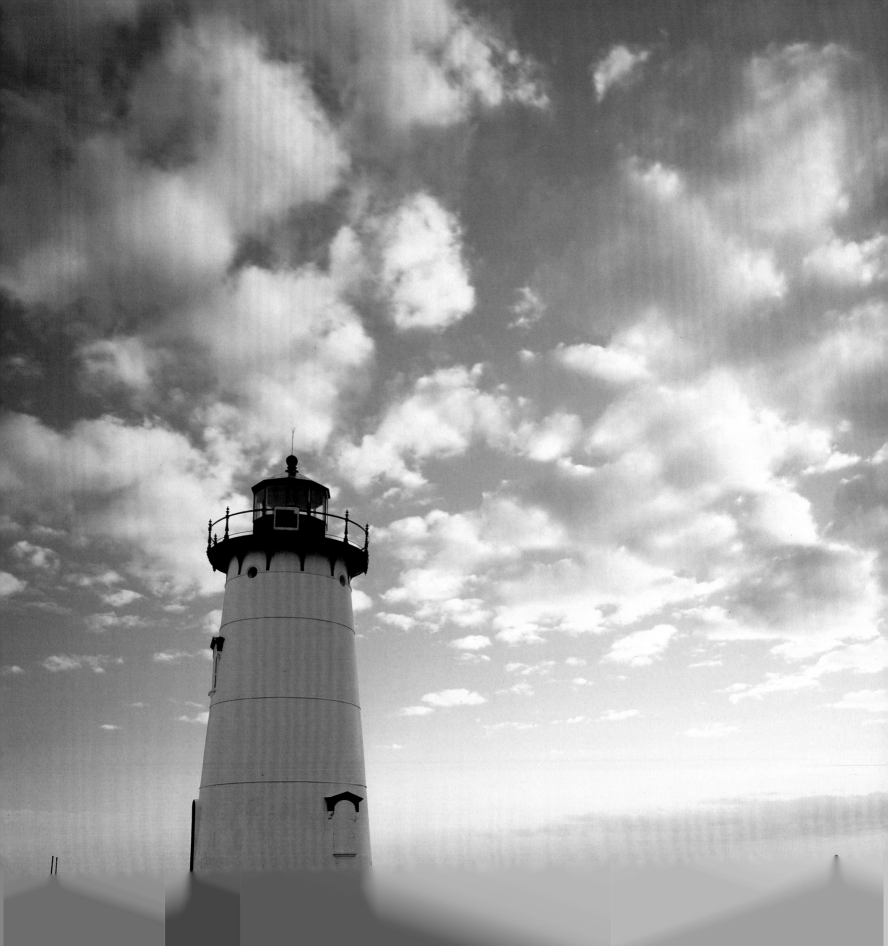

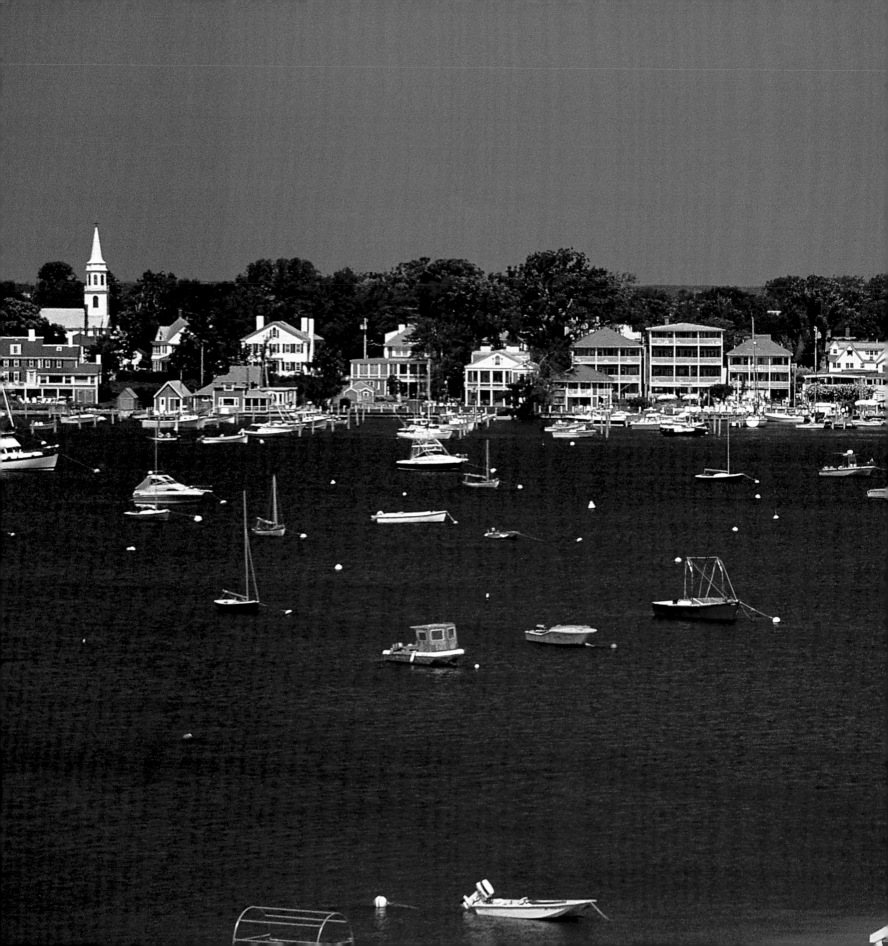

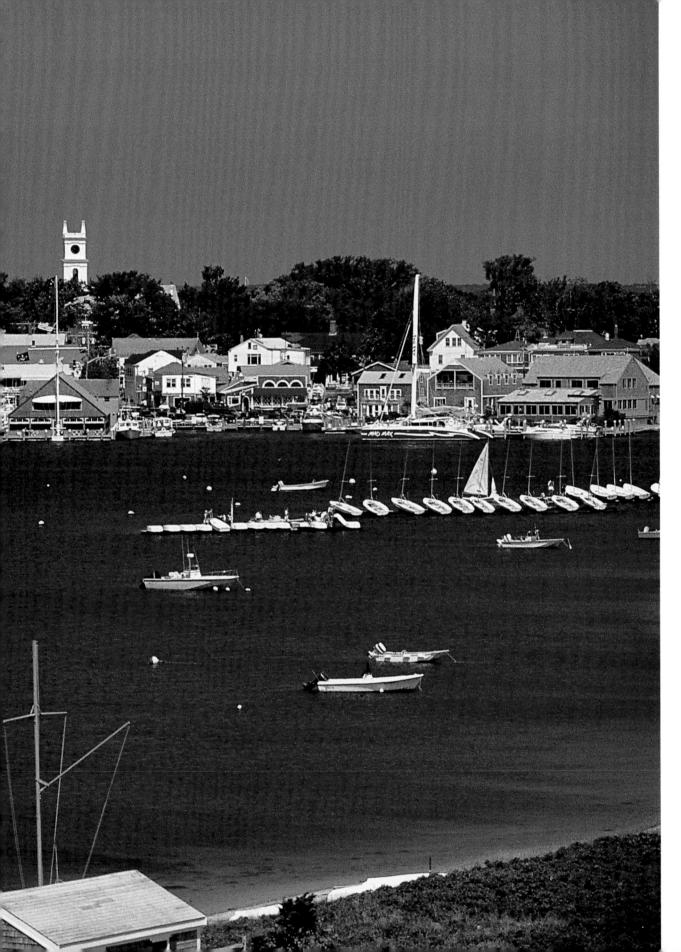

The elegant homes of Edgartown on Martha's Vineyard once belonged to sea captains, including more than 100 whalers, who collected china, art, and furniture from around the world to bring home to their wives. Many of the buildings here date from between 1830 and 1845.

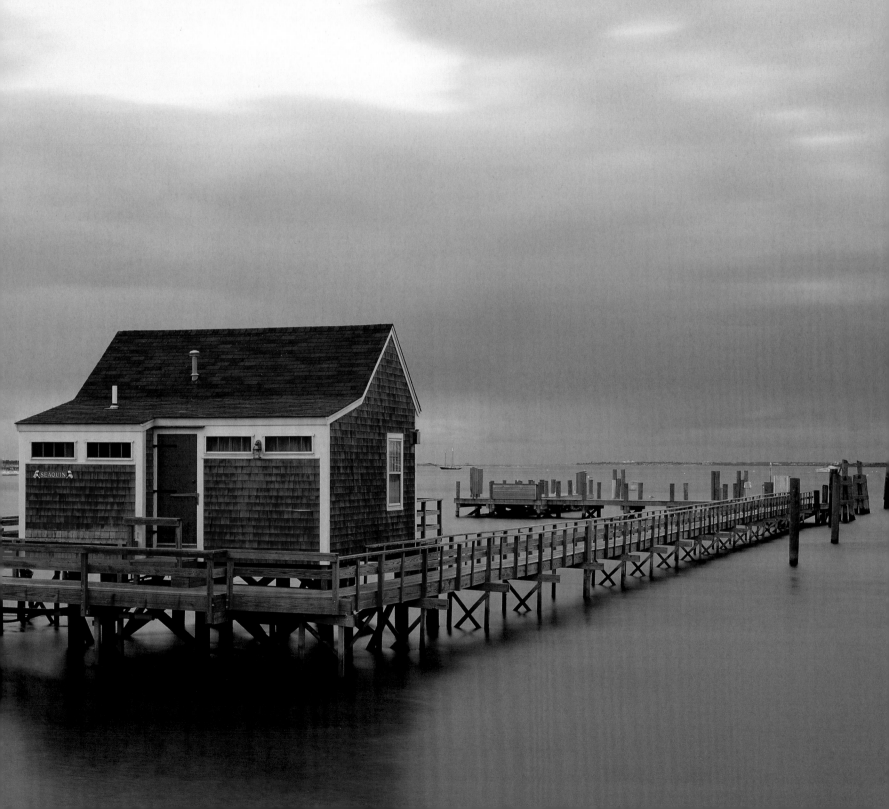

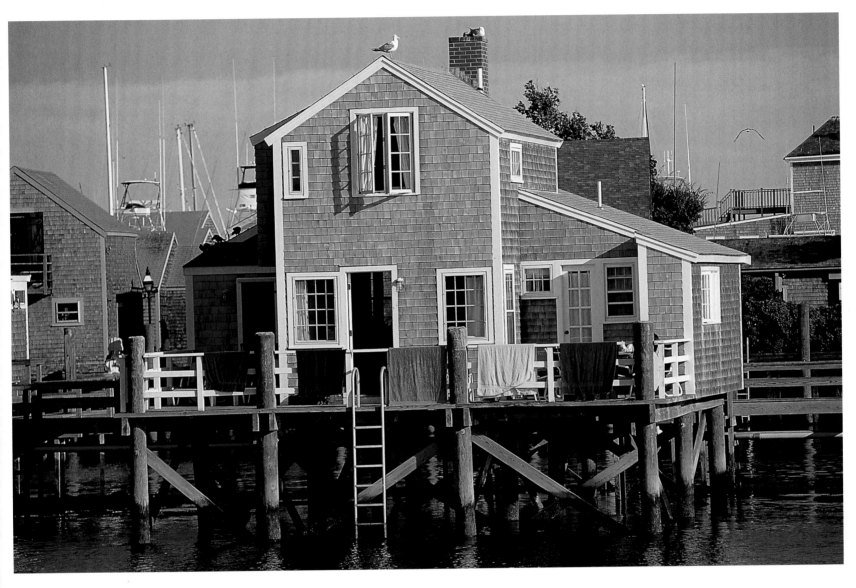

The first European settlers on the island of Nantucket arrived in 1659, seeking relief from the strict religious standards of the Massachusetts Bay Colony. A strong Quaker settlement later grew here.

Nantucket offers a unique array of artisans' wares, from jewelry made from antique whalebone to Nantucket lightship baskets, uniquely designed round vessels made on the island since the mid-1800s. Chocolates and candy, berry preserves, and even brews from a local microbrewery are available in the village shops.

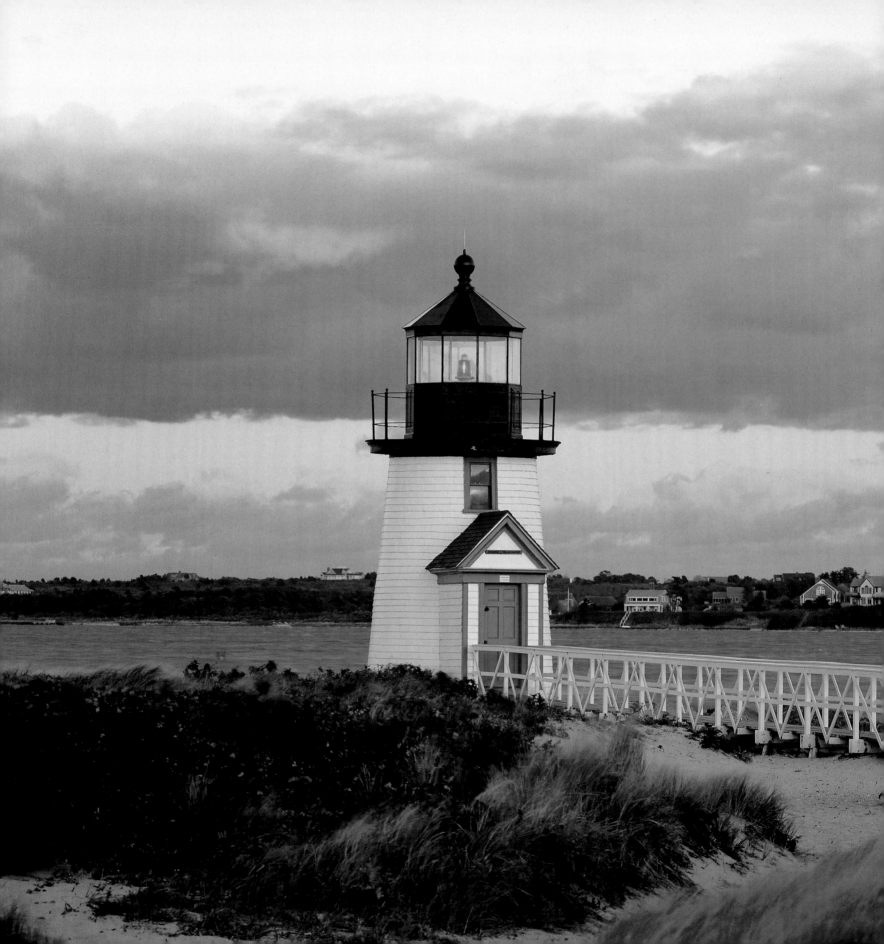

The Brant Point Lighthouse is the tenth beacon to warn sailors away from the cliffs of Nantucket. The first was built in 1746 and it and the following four were destroyed by fire or storms. The next four were progressively replaced by more modern lights. The present lighthouse was completed in 1901 and stands 26 feet high.

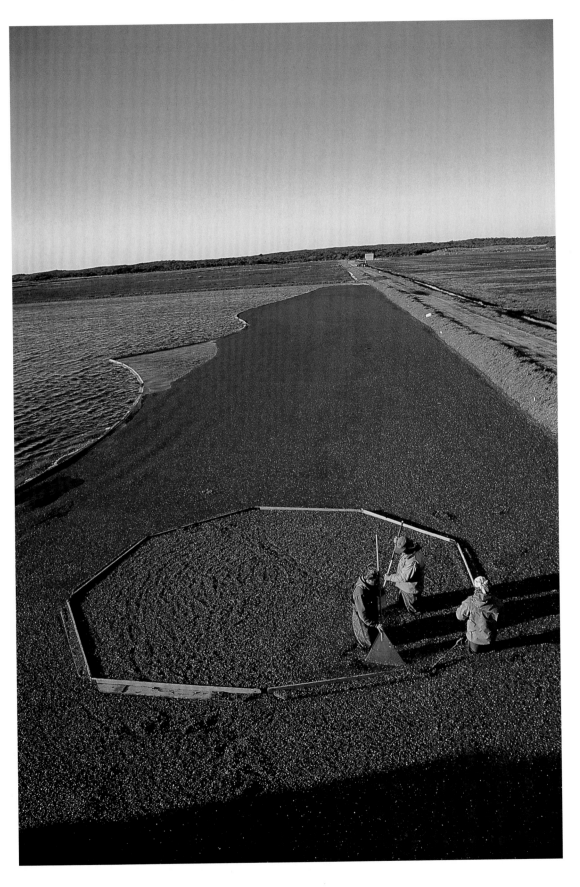

Cranberry growers flood the bogs for the harvest season each year. Massachusetts grows one-third of North America's cranberry crops and some of the plants in Cape Cod bogs are 150 years old.

FACING PAGE—
Nantucket's Lifesaving Museum celebrates the courage of the men and women who risked their lives over the past three centuries to save ship-wrecked sailors. Inside, visitors find examples of early lifesaving apparatus, from warning guns to beachcarts and surfboards, along with remnants and artifacts from vessels wrecked along the coast.

Clambakes are a Nantucket tradition. The hosts begin early in the day, stoking a fire on the beach and building a steam pit, using hot rocks. Then baskets of clams, lobster, and corn-on-the-cob are lowered into the pit and covered with a thick layer of seaweed to seal in the heat. The food emerges a few hours later, steaming and ready to eat.

FACING PAGE–
Whaling flourished in Nantucket for more than a century, reaching its peak between 1800 and 1840. With 88 ships, this was the whaling capital of the world and the industry's gains made the island prosperous.

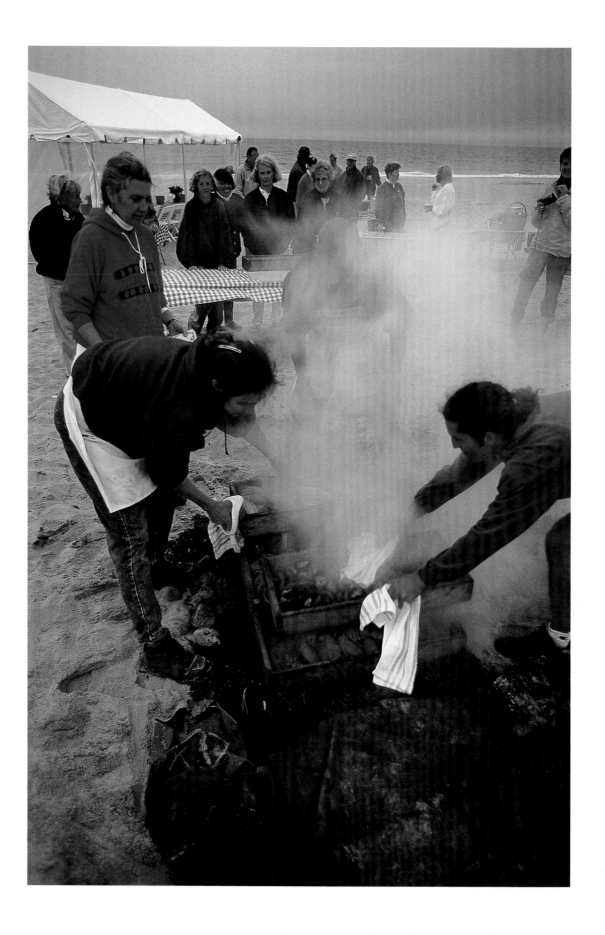

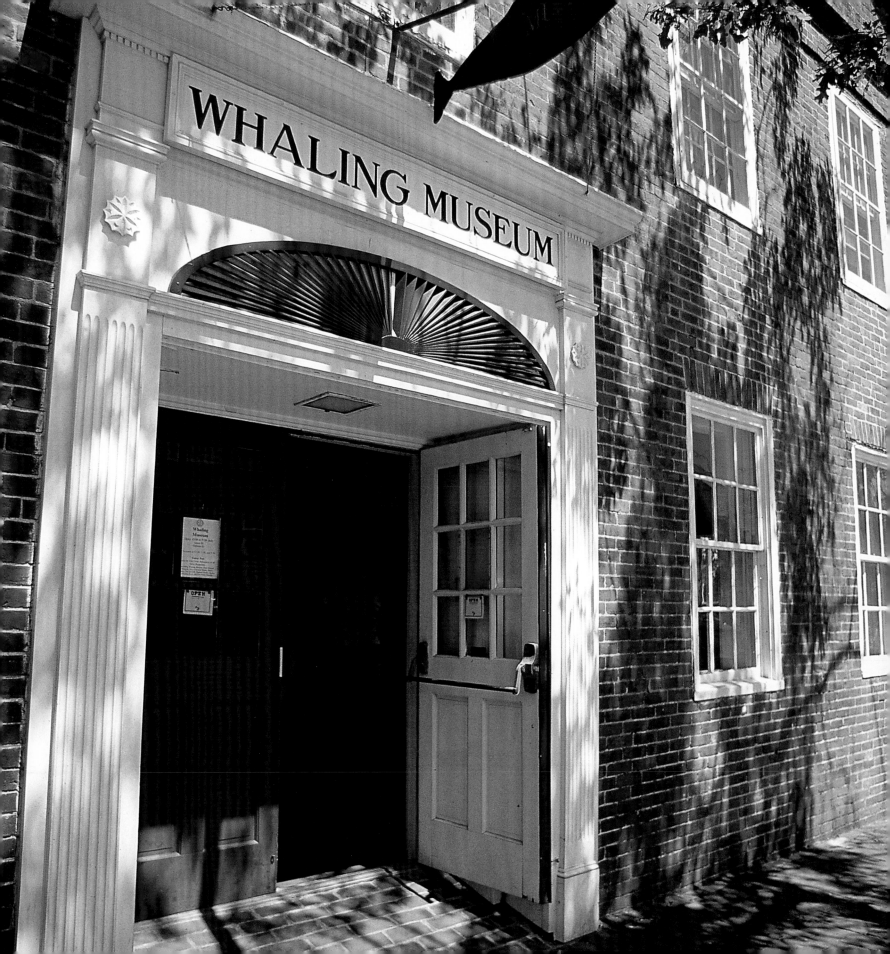

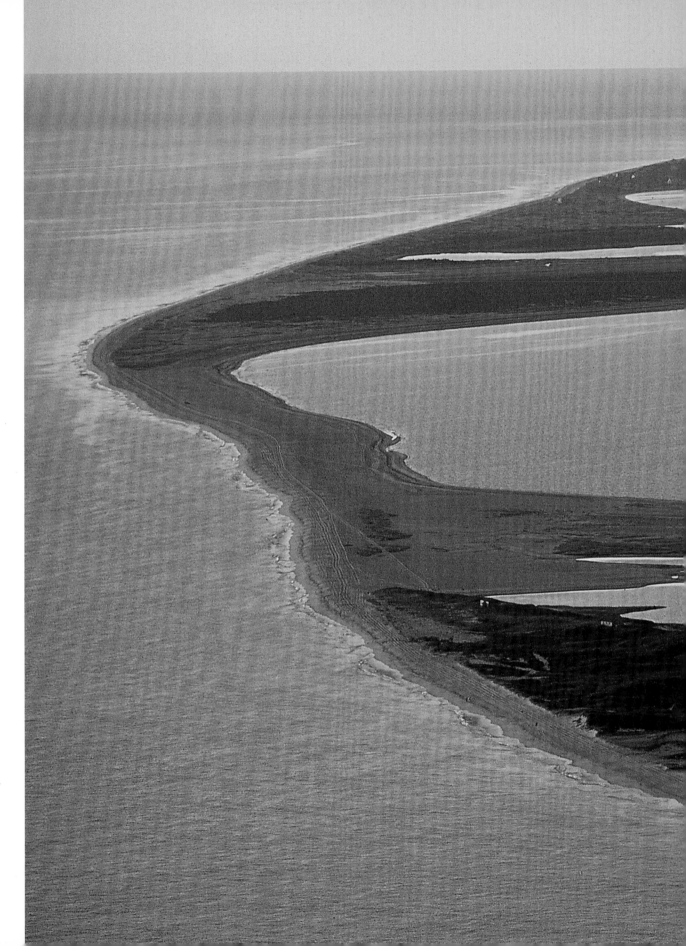

Great Point Light, designed to steer sailors through the channel between Nantucket and Monomoy islands, was built in 1785 and replaced with a stone tower in 1818. Despite the beacon, more than 40 ships floundered off the point in the latter half of the nineteenth century. The current beacon is a replica of the 1818 tower, which was destroyed in a 1984 storm.

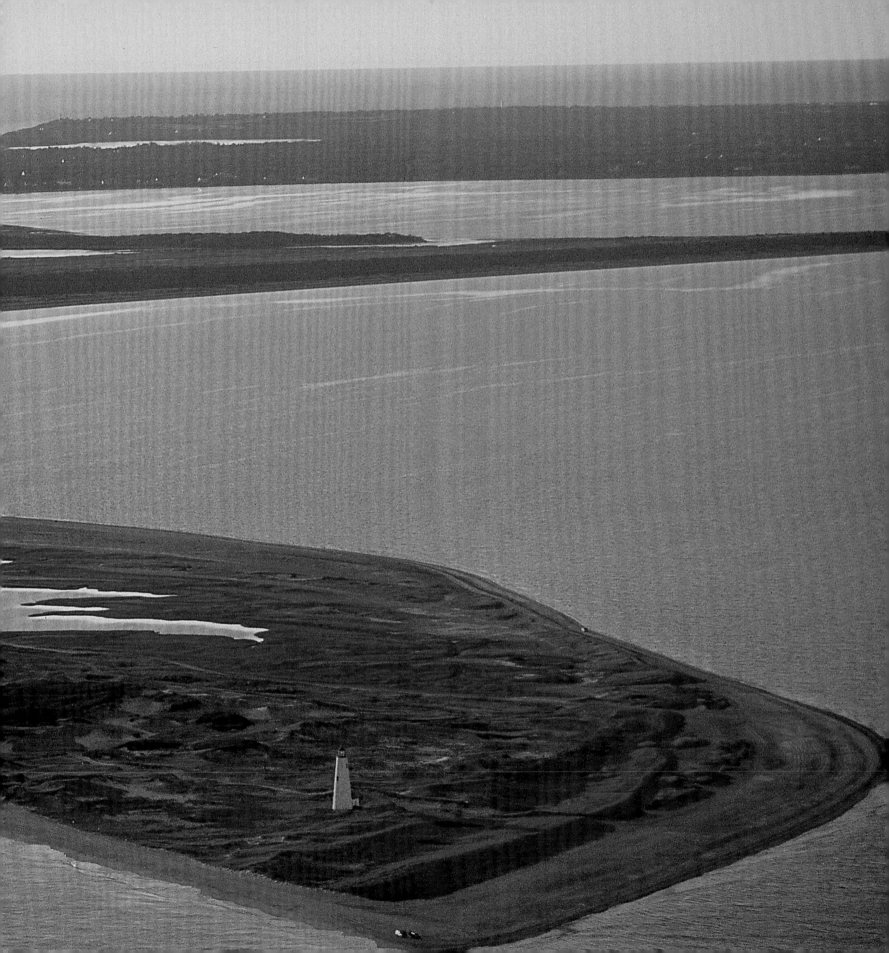

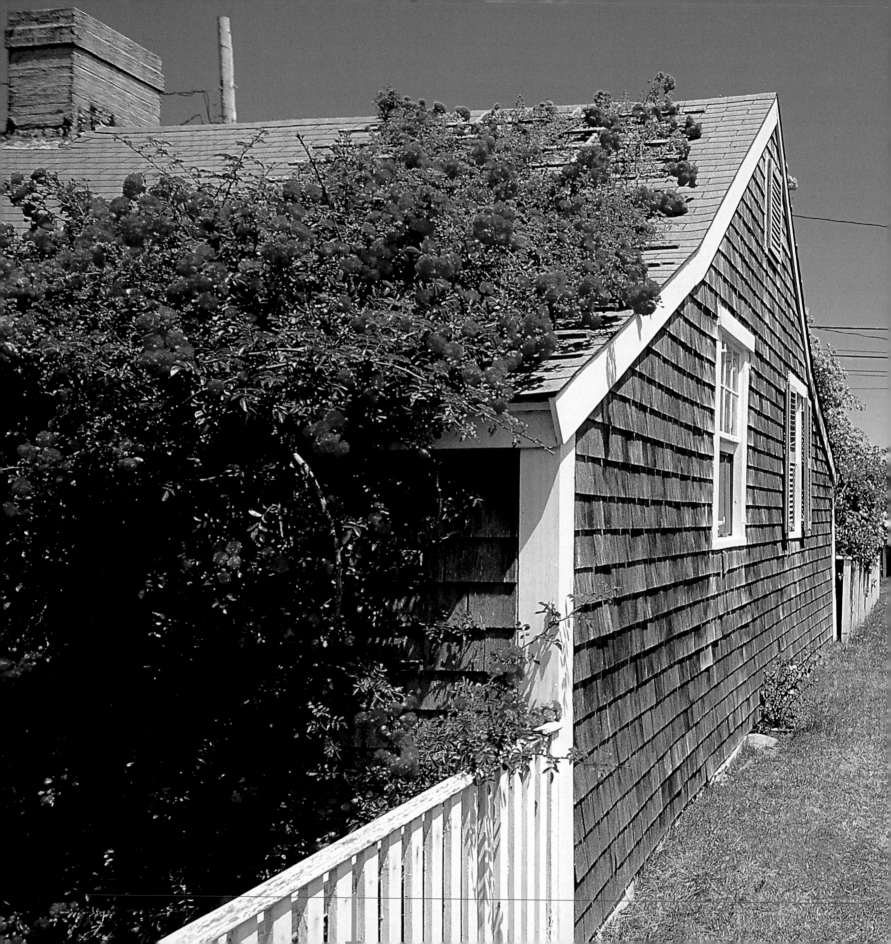

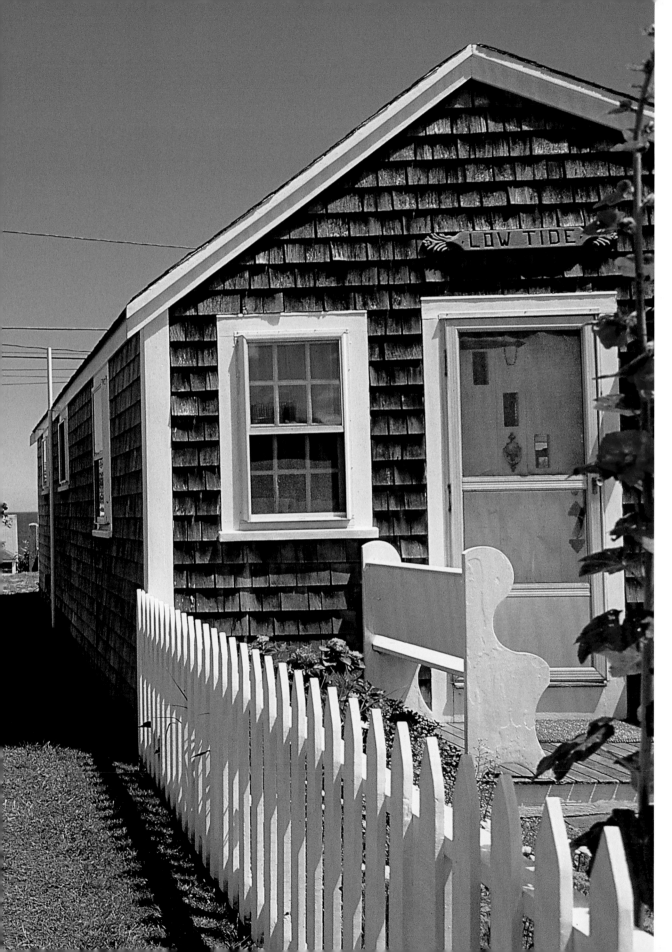

Nantucket encompasses only 48 square miles and is home to 9,000 residents, but its population swells to 40,000 each summer. Visitors searching for a less crowded venue might look to Siasconset, a tiny village on the eastern shore of Nantucket where cyclists peddle along the bluffs and climbing roses drape the rooftops.

89

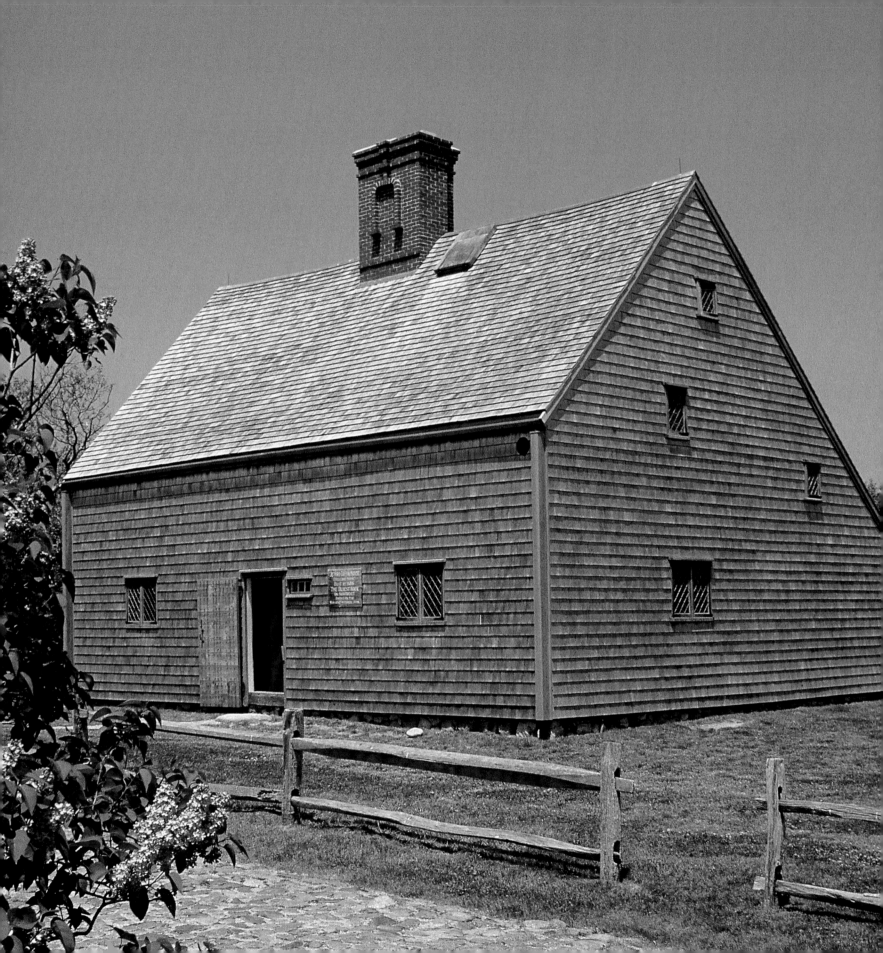

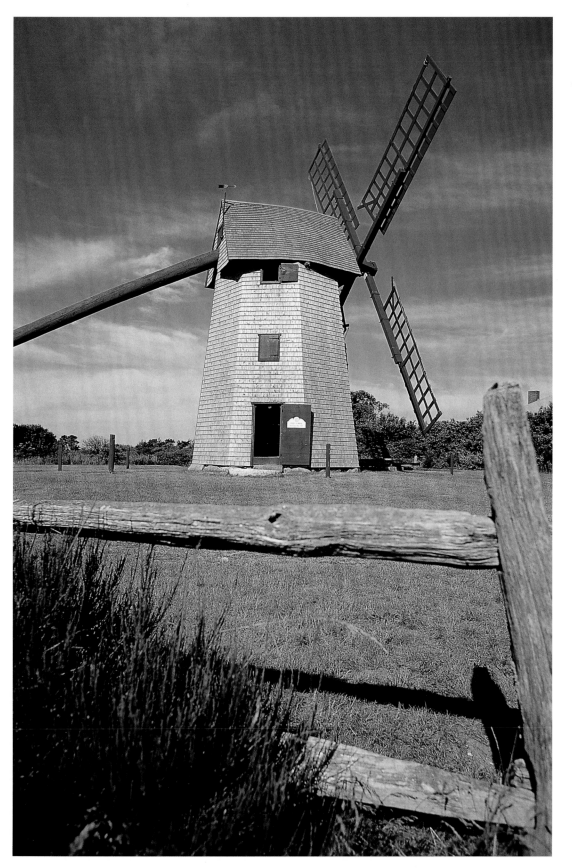

Four windmills once stood on Nantucket, serving the local settlers. Today only one survives, built in 1745 and donated to the Nantucket Historical Association in 1897. The mill operated commerically until 1892 and is still capable of grinding corn on a breezy day.

FACING PAGE–
Tristam Coffin and Mary Gardner Coffin were two of Nantucket's first European settlers. Their grandson, Jethro, built this house in 1686 and it has survived more than three centuries of winds and storms. As the oldest home on the island, it is preserved by the Nantucket Historical Association.

Buffeted by wind and waves, Cape Cod's barrier beaches change constantly. A single storm can move an entire sand dune or cut a trough through a beach to the earth behind. It's on these barrier beaches, where the shifting sands gradually give way to hardy grasses, that seabirds such as roseate terns and threatened piping plovers build their nests.

FACING PAGE—
Scenes such as this one are commonplace on Cape Cod, part of the reason painters, sculptors, writers, and artisans have flocked here for the past century. Master photographer Ansel Adams captured the Cape on film in the 1930s. Other famous artists who dot the region's past include Charles Hawthorne, founder of the Cape Cod School of Art, and painter and illustrator Edward Hopper.

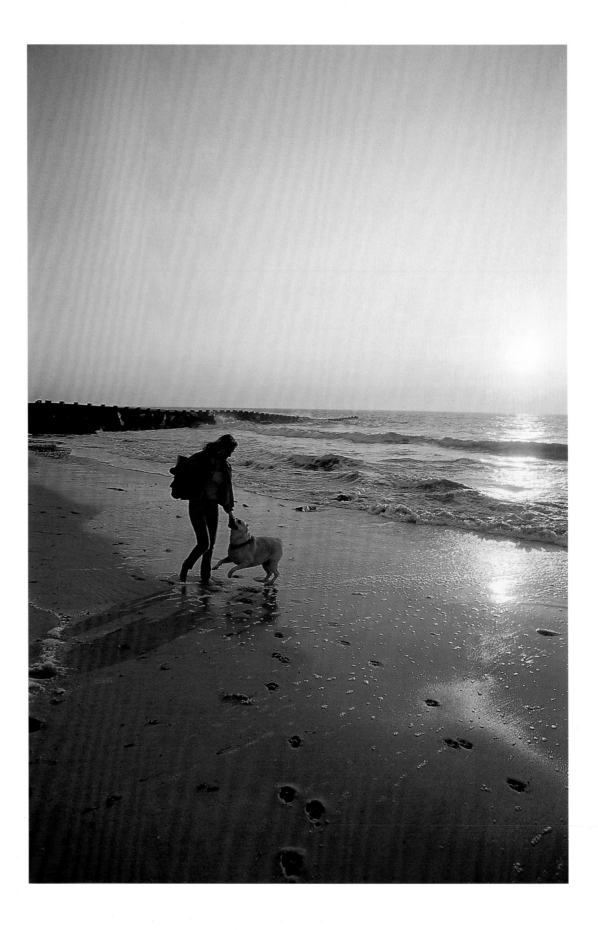

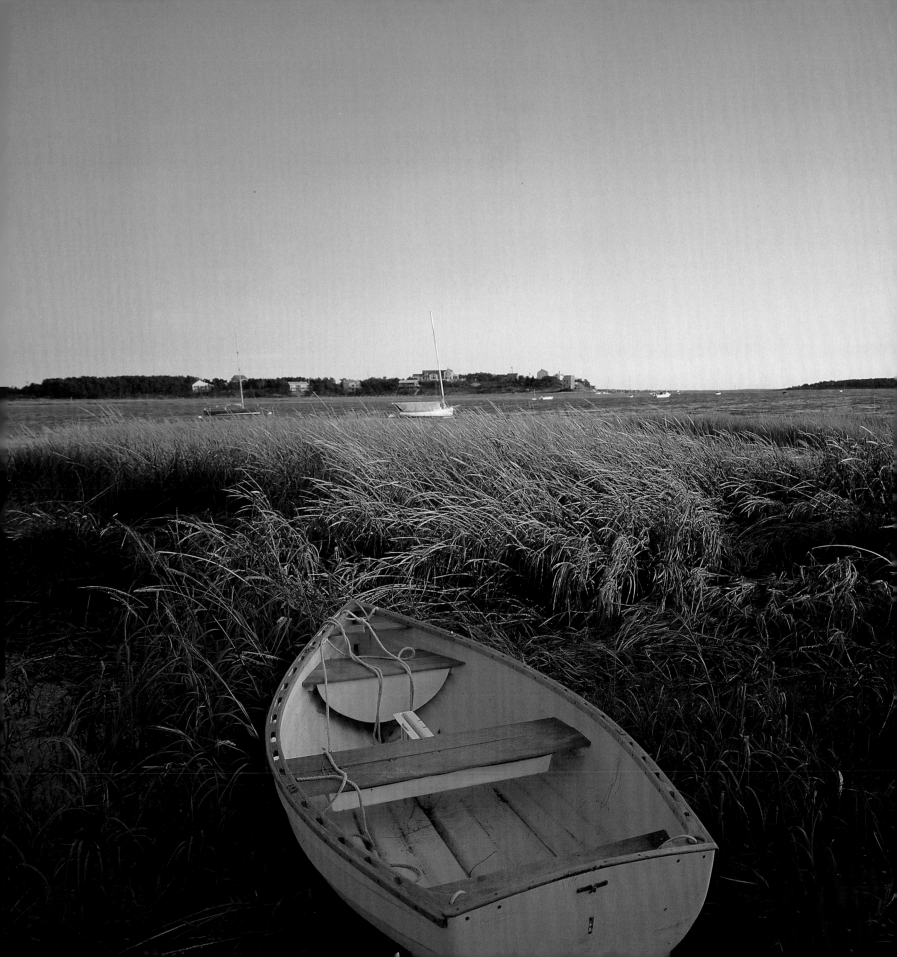

Nantucket may not offer the nightlife of Provincetown, but the pristine island possesses the highest concentration of historic buildings in the nation, along with long stretches of deserted white sand, quaint summer cottages, cranberry bogs, and moorlands.

Photo Credits